THIS FAR AND NO FURTHER

Focus on American History Series
The Dolph Briscoe Center for American History
University of Texas at Austin
Don Carleton, Editor

Photographs
Inspired by
the Voting Rights
Movement

WILLIAM
ABRANOWICZ

with Zander Abranowicz

THIS FAR AND NO FURTHER

FOREWORD BY
NIKOLE HANNAH-JONES

 University of Texas Press | Austin

Lucille Clifton, "slaveships," from *Blessing the Boats: New And Selected Poems 1988-2000*. Copyright © 2000 by Lucille Clifton. Reprinted by permission of BOA Editions, Ltd., www.boaeditions.org.

Requests for permission to reproduce material from this work should be sent to:
 Permissions
 University of Texas Press
 P.O. Box 7819
 Austin, TX 78713-7819
 utpress.utexas.edu/rp-form

♾ The paper used in this book meets the minimum requirements of ANSI/NISO Z39.48-1992 (R1997) (Permanence of Paper).

Library of Congress Cataloging-in-Publication Data

Names: Abranowicz, William, author, photographer. | Hannah-Jones, Nikole, writer of foreword.
Title: This Far and No Further : Photographs Inspired by the Voting Rights Movement / William Abranowicz ; with Zander Abranowicz ; foreword by Nikole Hannah-Jones.
Other titles: Focus on American history series.
Description: First edition. | Austin : University of Texas Press, 2021. | Series: Focus on American history series | Includes bibliographical references.
Identifiers: LCCN 2020010078 | ISBN 9781477321744 (cloth)
Subjects: LCSH: Civil rights movements—Southern States—History—20th century—Pictorial works. | Civil rights workers—Violence against—Southern States—History—20th century—Pictorial works. | African Americans—Violence against—Southern States—History—20th century—Pictorial works. | Civil rights demonstrations—Southern States—History—20th century—Pictorial works. | Civil rights movements—Southern States—History—20th century. | LCGFT: Photographs.
Classification: LCC E185.61 .A167 2021 | DDC 323.0973022/2—dc23
LC record available at https://lccn.loc.gov/2020010078

doi:10.7560/321744

To every American who fought and
continues to fight for equal access to the ballot.

FOREWORD

Nikole Hannah-Jones

When I give speeches across the country on racial caste in America, it is a disquieting revelation to the audience when I tell them that at the age of forty-three, I am part of the first generation of black people in the history of this country who were born having full legal rights of citizenship in the country of our birth. There is almost always a shocked silence. I choose to let the audience sit in that quiet for a moment, to sit in that discomfort, because my statement should not elicit surprise. You see, the math is not hard. I was born in 1976. That's a mere decade after the height of the civil rights movement, when upon the blood sacrifice of thousands of Black Americans, this nation begrudgingly passed laws outlawing racial discrimination across American life. A mere thirteen years after President Lyndon Baines Johnson signed the Voting Rights Act to once again guarantee for black citizens our most hallowed right—the right to vote—fully a century after we had been guaranteed that very same right with the Fifteenth Amendment.

I let them sit in their shock and discomfort because I hope that it will shake the shared complicity of forgetting in which they—in which we—have engaged.

We are a country born of slavery followed by one hundred years of codified legal racism. It is a past so recent that we do not need to even squint to see it. We can look in our grocery stores, our restaurants, our libraries, our universities, and our boardrooms, even in Congress itself, and see both the living victims and the living perpetrators of racial apartheid. We saw Rep. John Lewis and somehow overlooked that he nearly died on the Edmund Pettus Bridge in Selma over voting rights for Black Americans—for which, in 2020, he was still fighting. We somehow pretend that it is not a damning truth that majority-black Montgomery, Alabama, the home of the famous bus boycott, did not elect its first black mayor until 2019. That it is just a superficial fact that the segregationist Strom Thurmond served in Congress until I was in middle school. That my father, like millions of Americans alive right now, was born into an apartheid state. That still standing are the libraries his family could not use, the restaurants where they could not dine, the schools they could not attend. That in 2019, they had to bullet-proof the plaque commemorating the murder of a child just a few years older than my father, a child whose body was tossed into the Tallahatchie River because white men believed he had committed the capital crime of not paying proper deference to a white woman.

The truth is that at the same time America was evangelizing democracy to the rest of the world, white Americans were violently suppressing democracy for millions of citizens here. The reality is that while we consider ourselves the greatest and most liberatory democracy in the world, we continue to this day to try to suppress the vote of those considered unworthy of self-rule, of those considered half-citizens still.

But, alas, we are more invested in forgetting than in truth, in hiding the crimes than in confronting them. The innocuous landscape that *This Far and No Further* details in photography—chairs and papers, ceiling fans and deserted country roads—hides the blood, the sorrow, the death. The dignified faces of the architects of racial equality, the true vanguards of democracy, contained within the pages of this book belie the horrors they witnessed and survived.

So much abominable violence was endured in trying to make this country the land of the free that we prefer not to look at it. But there is a violence, too, in the forgetting. These photos, haunting only because we know the truth behind them, force that confrontation. In their ordinariness, they confront the ordinariness of the violence. And it is only in the confrontation of the crimes that we can begin to make things right.

PREFACE

William Abranowicz

Fifty years after my father took me to see the Newark riots and fifty-two years after the historic marches from Selma to Montgomery, Alabama, I found myself in Selma on break from an assignment in nearby Lowndes County. In 2017, Selma seemed unchanged from the city that Walker Evans photographed for the Farm Security Administration in the 1930s. My walk over the arch of the Edmund Pettus Bridge was transformative. Reaching the apex, I imagined the sea of blue-helmeted Alabama State Police, many on horseback, flanking Dallas County Sheriff Jim Clark and hundreds of hate-fueled "vigilante" white citizens awaiting the signal to attack their prey. I stood at the point where twenty-five-year-olds like John Lewis and Hosea Williams led some six hundred peaceful marchers toward this blue wall of local police, state troopers, and posse members. On the shoulder of the road, at the spot where Lewis and his comrades were beaten with clubs, I thought about my children, then near Lewis's age, and about President Barack Obama's ceremonial walk over that same arch just two years before my visit, when he and surviving participants of the civil rights movement commemorated the fiftieth anniversary of the Selma marches.

On that first visit, I was struck by the chords—emotional, historical, and visual—that drive my work as a photographer. Inspired, I returned to Alabama a month later to begin tracing the events leading up to the Selma-to-Montgomery Marches of 1965. Again and again, I returned to the South with my camera to explore connections between history, justice, and the vote. To Dr. Martin Luther King Jr., the right to vote was supreme, eclipsing and containing within it all other rights. Dr. King's young colleague Congressman John Lewis has lamented the number of people who "suffered, struggled, and died to make it possible for every American to exercise the right to vote." It is almost miraculous that the indignity of disenfranchisement, along with the suffering and death that civil rights activists and sympathizers faced, rarely provoked them to reciprocate with violence of their own. As years of struggle passed, however, voices naturally emerged within the movement that reflected James Baldwin's prescient warning: "No state has been able to foresee or prevent the day when their most ruined and abject accomplice—or most expensively dressed prostitute—will growl, 'this far and no further.'"

Among nations, America has been uniquely active in preventing people of color and the poor from voting. Voter-suppression efforts didn't end with the Voting Rights Act of 1965. In 2013, the Supreme Court struck "preclearance," which required federal approval on any changes in voting and election laws in regions with significant histories of racially motivated disenfranchisement: Alabama, Alaska, Georgia, Louisiana, Mississippi, South Carolina, and Virginia, as well as several counties in four other states. With the 2016 election of President Donald Trump, efforts to limit access to the vote have accelerated. Today, restrictions to ballot access are enforced less by threat of physical violence than by subtler methods no less sinister: surgically administered, legislatively approved, and judicially unchallenged gerrymandering; the widespread closure of polling stations; enhanced voter identification requirements; early voting cutbacks; and registration restrictions. Collectively, these measures minimize access to the ballot for students, working people, and people of color. Is this the democracy we claim to represent at home and abroad?

The stirring experience I had on the Pettus Bridge was repeated as I moved through the Southeast. When I stood in places where hate and violence reigned for centuries—where enslaved people were bought and sold by white people of supposed higher intelligence, moral standing, and relation to God—I came to understand that America has blood and shame soaked into its soil. Heavy air, beautiful golden light, remarkable natural history, stunning landscapes, and rich lore all contribute to the mystique of the South, but this coexists with a history of extraordinary violence. Violence may be woven within American memory, but the South's interpretation of that memory is unique.

Many died to procure the right to vote. Many more were beaten. And many untold more were scarred by the psychological toll of life under American apartheid. Though excited and inspired on that first walk in Selma, I was angered and haunted as my journey progressed. I'm ashamed to say that I had never properly acknowledged the obvious. I was shielded from this history—much of which occurred within my lifetime—by white privilege. But eventually, my anger gave way to something more powerful: resolve. It wasn't enough for me to recognize I was part of the problem. With my modest means, I wanted to offer a solution—a solution to the problem of historical amnesia.

Early in this project, a young Black American man who grew up in Sumner, Mississippi—the town in which Emmett Till's killers were acquitted in 1955—asked how I got started on this journey. I naively said that voter suppression simply seemed very un-American to me, considering all that our countrymen had given to secure voting rights.

Without a moment's delay, he replied, "Maybe it's very American."

THIS FAR AND NO FURTHER

PART I
MORTAL SIN

Chenal, Pointe Coupee Parish,
Louisiana, 2019

slaveships

loaded like spoons
into the belly of Jesus
where we lay for weeks for months
in the sweat and stink
of our own breathing
Jesus
why do you not protect us
chained to the heart of the Angel
where the prayers we never tell
and hot and red
as our bloody ankles
Jesus
Angel
can these be men
who vomit us out from ships
called Jesus Angel Grace of God
onto a heathen country
Jesus
Angel
ever again
can this tongue speak
can these bones walk
Grace Of God
can this sin live

Lucille Clifton

Charleston, South Carolina, 2018

This slaveship portrait is displayed in Charleston's Liberty Square. Forty percent of African people brought to the United States as slaves passed through the city of Charleston. In 2018, the Charleston City Council formally apologized for Charleston's role in the slave trade while gathered in a chamber in the city hall, which had been built by enslaved people.

Traders of enslaved people traded in children as well as adults. The following, taken from slaveship manifests, lists the names, ages, and heights of some of these young victims:

Ofam, boy, age 7, height 3'10"
Yamasa, boy, age 6, height 4'2"
Acconowah, girl, age 5, height 4'1"
Chewhobak, girl, age 7, height 4'2"
Acon, boy, age 7, height 4'
Toukaree, boy, age 6, height 2'8"
Marpoo, girl, age 7, height 3'11"
Parjoo, girl, age 9, height 4'4"
Mardaa, girl, age 7, height 4'2"
Smaw, boy, age 5, height 4'11"

Accomah, girl, age 4, height 4'8"
Joquoi, girl, age 6, height 4'4"
Abee, boy, age 8, height 4'4"
Manjang, boy, age 9, height 4'5"
Abong, boy, age 5, height 4'
Kobah, girl, age 9, height 4'2"
Dondokee, girl, age 5, height 3'8"
Asang, boy, age 11, height 4'7"
Susoo, girl, age 8, height 4'
Malangah, girl, age 6, height 3'4"
Ahdonee, boy, age 3, height 3'5"
Allahboloo, girl, age 3, height 3'
Ahgassy, boy, age 3, height 2'4"
Degbay, girl, age 10, height 4'3"
Ahbong, boy, age 10, height 4'
Immoh, girl, age 9, height 4'6"
Comahsah, girl, age 4, height 3'5"
Alekah, girl, age 5, height 3'8"
Akamoo, boy, age 8, height 3'9"
Wambay, boy, age 8, height 3'10"
Annanah, boy, age 6, height 3'8"
Lamboh, girl, age 9, height 4'5"
Oyoyah, boy, age 4, height 3'1"
Bang, girl, age 11, height 4'7"
Fatahday, boy, age 7, height unknown

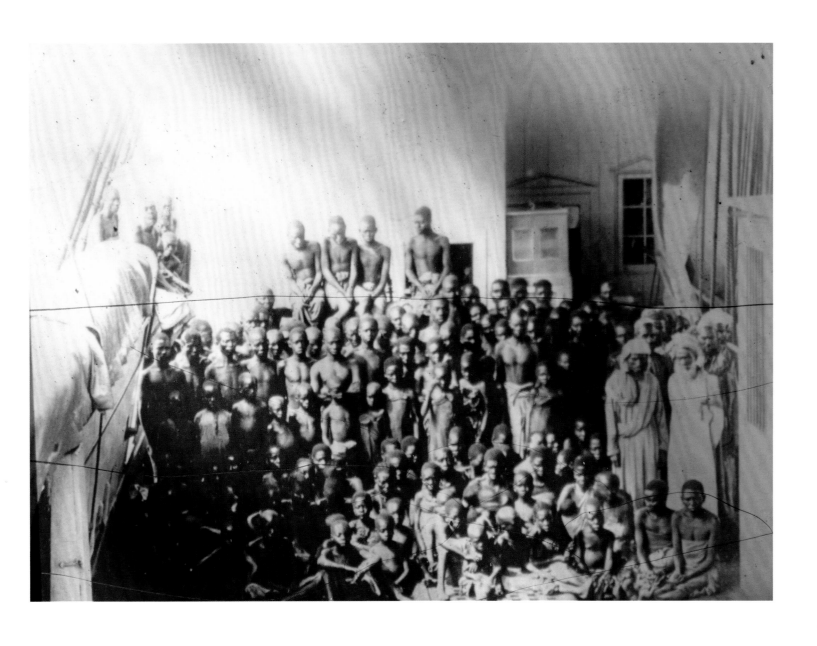

The Alabama River, Montgomery, Alabama, 2018

The advent of steam-powered riverboats allowed traders of enslaved people to efficiently transport human cargo from major ports such as New Orleans to key markets in the lower South, using routes such as the Alabama River, shown here from Montgomery's Commercial Street. By the 1840s, steamboats were delivering hundreds of enslaved people daily to Montgomery and other trading centers. In Montgomery, the former slave market is now the home of the Equal Justice Initiative.

(previous spread)
Irrigation Ditch, Lowndes County, Alabama, 2017

This twenty-foot-wide irrigation ditch, dug by enslaved people in the nineteenth century, is located in Hayneville, Alabama. In 1850, there were 16,100 recorded cotton plantations in the state of Alabama, and over the following decade, cotton production there doubled, with nearly half of the output originating in Alabama's "Black Belt" plantations. Cotton remained America's leading export until 1937.

The White House, Washington, DC, 2015

This wallpaper, which depicts an idealistic view of American racial harmony in the 1820s, now hangs in the White House Diplomatic Reception Room. It was salvaged from a Maryland estate facing demolition and presented to Jacqueline Kennedy in 1961 during the redecoration of the White House following her husband's election to the presidency. Originally produced in France in 1834 by Jean Zuber and Company, the artwork was inspired by French engravings of American sites from the 1820s.

It portrays the harmonious interaction of Native Americans, blacks, and whites around Boston Harbor, New York Harbor, Niagara Falls, West Point, and the Natural Bridge of Virginia—a romanticized version of American society by admiring French observers.

**Cotton Field, Lowndes County,
Alabama, 2017**

Enslaved people faced miserable con-
ditions when working the cotton fields,
such as this one in Alabama. Arguing
for slavery's necessity to the cotton
trade, Mississippi's Articles of Secession
stated: "These products are peculiar
to the climate verging on the tropical
regions, and by an imperious law of
nature, none but the black race can bear
exposure to the tropical sun."

**State Capitol, Montgomery,
Alabama, 2017**

This star on the steps of Alabama's
State Capitol marks the spot where
Jefferson Davis, a US senator from
Mississippi, was inaugurated president
of the Confederate States of America
on February 18, 1861.

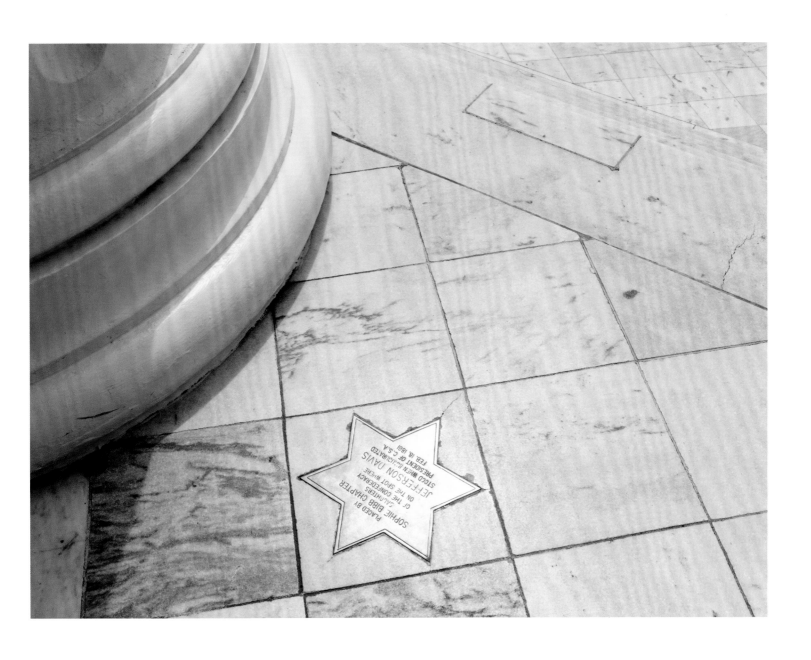

SOPHIE BIBB CHAPTER
DAUGHTERS
OF THE CONFEDERACY
ON THE SPOT WHERE
JEFFERSON DAVIS
STOOD WHEN INAUGURATED
PRESIDENT OF C.S.A.
FEB. 18, 1861

(*previous spread*)
State Capitol Trees, Jackson, Mississippi, 2018

These trees at Mississippi's State Capitol evoke a dark history. Intimidation of and retribution against any Black American who voted, tried to register to vote, or assisted any other citizen in registering or voting was common prior to the Voting Rights Act of 1965. Even minor infractions to the accepted white social order could lead to economic ruin, job loss, violence, or lynching. The Equal Justice Initiative documents more than 6,500 lynchings between 1877 and 1950 in the twelve most active lynching states: Alabama, Arkansas, Florida, Georgia, Kentucky, Louisiana, Mississippi, North Carolina, South Carolina, Tennessee, Texas, and Virginia. Lynchings peaked in the 1890s.

Green-Meldrim House, Savannah, Georgia, 2018

When the Union army under General William Tecumseh Sherman occupied Savannah in 1864, the owner of the Green-Meldrim House offered the residence as headquarters for Sherman's staff. There, General Sherman issued Special Field Order No. 15, commonly known as "Forty Acres and a Mule," which granted formerly enslaved citizens an average of forty acres of expropriated land, totaling 400,000 acres from "the islands from Charleston, south, the abandoned rice fields along the rivers for thirty miles back from the sea, and the country bordering the St. Johns River, Florida." No whites would be permitted to settle in this area. The federal government under President Andrew Johnson reneged on the agreement after President Abraham Lincoln's assassination.

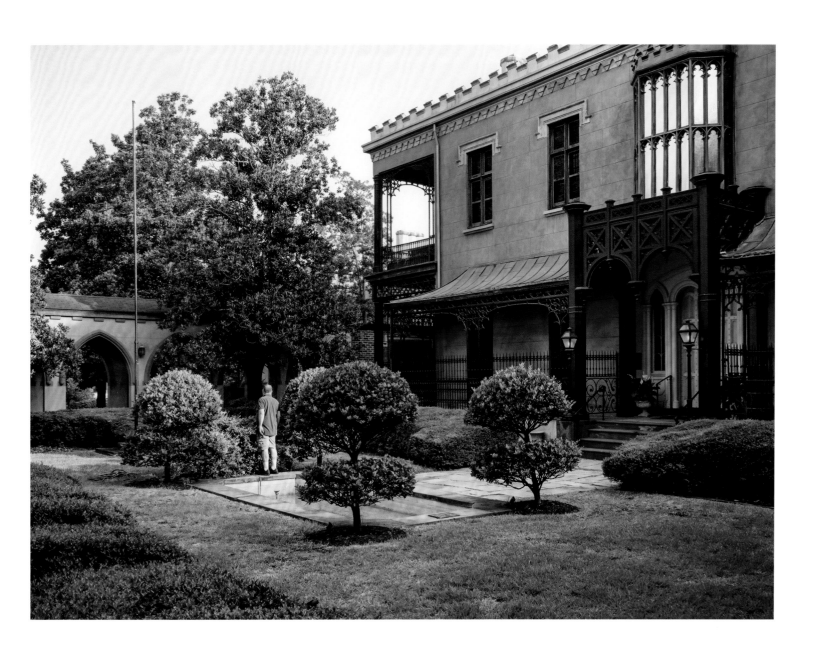

Market Street, Wilmington, North Carolina, 2019

The 1898 Wilmington coup is our nation's only recorded coup d'état, occurring less than one mile from where this garage stands today. The putsch was organized and executed by a group of white supremacist Democrats determined to wrest power from the recently elected, biracial Fusionist government. Over the course of November 10, a posse murdered somewhere between fourteen and sixty black men, banished twenty more, and forced the resignations of the mayor, police chief, and members of the board of aldermen.

Brooklyn Neighborhood, Wilmington, North Carolina, 2019

After Reconstruction, North Carolina saw the rise of the Fusion Party, a coalition of black Republicans and Populists uniting poor whites and freed slaves against white supremacy. Their ascendance triggered a violent backlash that included an 1898 coup in Wilmington, where a racially fueled killing spree swept through the city's Brooklyn neighborhood, which was majority black and home to many Fusionist leaders and supporters.

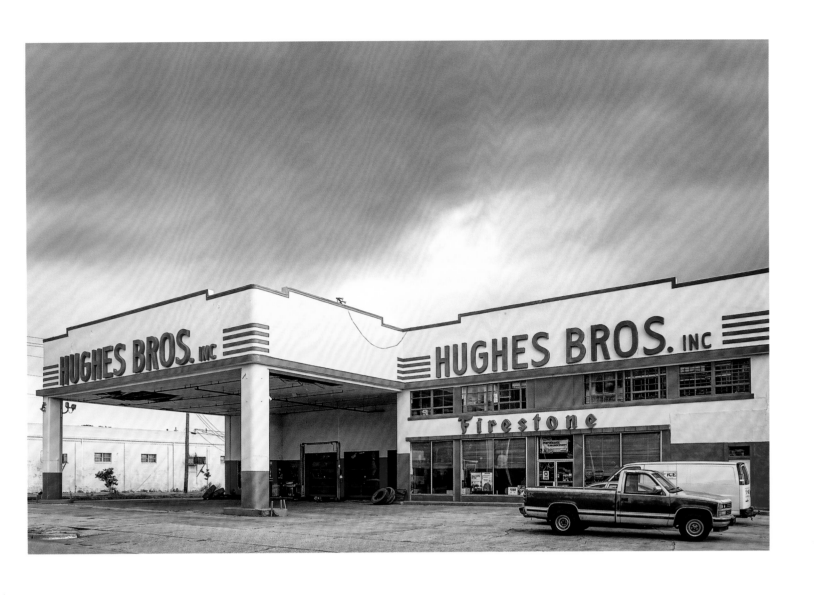

Beale Street, Memphis, Tennessee, 2019

Dual water fountains, such as this one in Memphis, were common tools of segregation during the Jim Crow era. Jim Crow was a concerted response to heightened black aspirations in the early years of Reconstruction, when formerly enslaved citizens found themselves with access to the vote, land, education, and employment. Segregation was designed to suppress this brief moment of optimism.

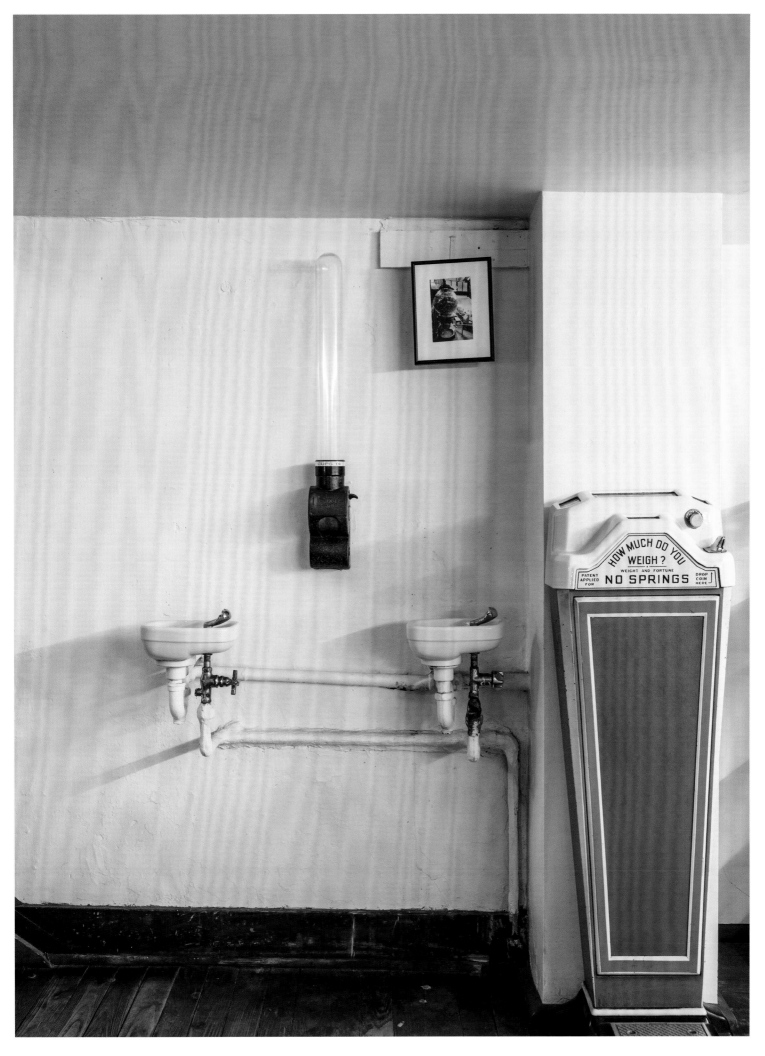

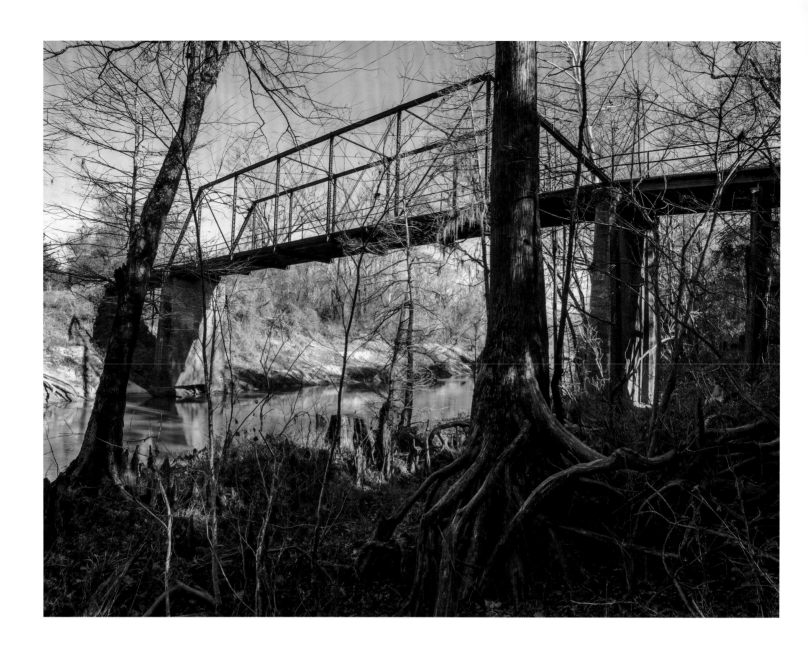

Bridge, Shubuta, Clark County, Mississippi, 2018

Six documented lynchings occurred at this bridge in Clark County. Two young men and two young pregnant women were hanged here in 1918, as were two young boys in 1942. No one was ever brought to justice for these crimes. During the civil rights movement, violence against organizers in Clark County was meted out intensely and swiftly, preventing almost any civil rights activity from occurring there in the 1960s.

Sloss Furnaces, Birmingham, Alabama, 2018

Birmingham was the South's first major industrialized city, with significant iron ore smelting facilities operated by a largely black labor force. Sloss Furnaces, founded in 1882 by Colonel James Withers Sloss, a former Confederate colonel, paid employees the lowest wages in the industry and prevented unionization through violence and intimidation. After the retirement of Colonel Sloss, the reorganized Sloss-Sheffield Steel and Iron Company, in collusion with local sheriffs, began to depend on a system of peonage in which mainly black convicts were "leased" to the company without pay. This system of wage slavery was pioneered in the South by another former Confederate officer, General Nathan Bedford Forrest, who introduced it in Tennessee in 1875. The practice of convict leasing continues today throughout the United States. Sloss Furnaces, a National Historic Landmark, is now an arts and education center.

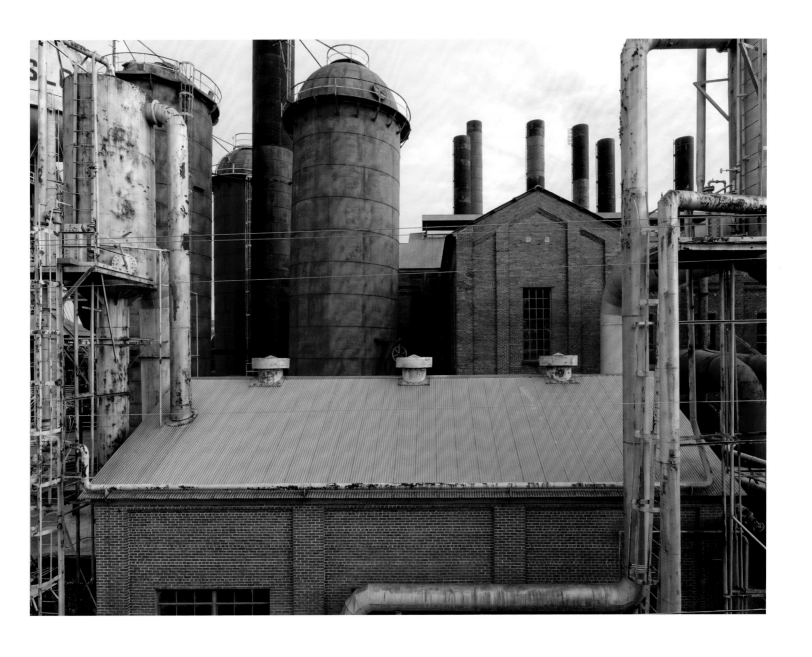

15. If a vacancy occurs in the U.S. Senate, the state must hold an election, but meanwhile the place may be filled by a temporary appointment made by

_____.

16. A U.S. senator is elected for a term of _____ years.

17. Appropriation of money for the armed services can be only for a period limited to _____ years.

18. The chief executive and the administrative offices make up the _____ branch of government.

19. Who passes laws dealing with piracy?

20. The number of representatives which a state is entitled to have in the House of Representatives is based on

21. The Constitution protects an individual against punishments which are _____ and _____.

22. When a jury has heard and rendered a verdict in a case, and the judgment on the verdict has become final, the defendant cannot again be brought to trial for the same cause.
_____True _____False

23. Name two levels of government which can levy taxes:

24. Communism is the type of government in: _____U.S.
_____Russia
_____England

25. Cases tried before a court of law are two types, civil and

_____.

26. By a majority vote of the members of Congress, the Congress can change provisions of the Constitution of the U.S.
_____True _____False

27. For security, each state has a right to form a

_____.

28. The electoral vote for President is counted in the presence of two bodies. Name them:

29. If no candidate for President receives a majority of the electoral vote, who decides who will become President?

30. Of the original 13 states, the one with the largest representation in the first Congress was

31. Of which branch of government is the Speaker of the House a part?
_____Executive
_____Legislative
_____Judicial

32. Capital punishment is the giving of a death sentence.
_____True _____False

33. In case the President is unable to perform the duties of his office,

who assumes them?

34. "Involuntary servitude" is permitted in the U.S. upon conviction of a crime.
_____True _____False

35. If a state is a party to a case, the Constitution provides that original jurisdiction shall be in
_____.

36. Congress passes laws regulating cases which are included in those over which the U.S. Supreme Court has
_____ jurisdiction.

37. Which of the following is a right guaranteed by the Bill of Rights of the U.S. Constitution.
_____Public Housing
_____Education
_____Voting
_____Trial by Jury

38. The Legislatures of the states decide how presidential electors may be chosen.
_____True _____False

39. If it were proposed to join Alabama and Mississippi to form one state, what groups would have to vote approval in order for this to be done?

40. The Vice President presides over
_____.

41. The Constitution limits the size of the District of Columbia to
_____.

42. The only laws which can be passed to apply to an area in a federal arsenal are those passed by _____ provided consent for the purchase of the land is given by the
_____.

43. In which document or writing is the "Bill of Rights" found?
_____.

44. Of which branch of government is a Supreme Court justice a part?
_____Executive
_____Legislative
_____Judicial

45. If no person receives a majority of the electoral votes, the Vice President is chosen by the Senate. _____True _____False

46. Name two things which the states are forbidden to do by the U.S. Constitution.

47. If election of the President becomes the duty of the U.S. House of Representatives and it fails to act, who becomes President and when?

48. How many votes must a person receive in order to become President if the election is decided by the U.S. House of Representatives?

**George Lee Street,
Belzoni, Mississippi, 2018**

(*previous spread*)
**Copy of Literacy Test,
Selma, Alabama, 2017**

Literacy tests such as this one were key
mechanisms in the legal disenfranchise-
ment of Black Americans from the end
of Reconstruction to the 1960s. These
almost impossible-to-pass exams often
excluded poor whites and immigrants
from the ballot box as well.

George Washington Lee was a black
minister in Belzoni. In 1953, Lee and Gus
Courts, a black grocer, cofounded a local
chapter of the NAACP (National Asso-
ciation for the Advancement of Colored
People), which successfully registered
nearly all the county's black voters by
1955. That same year, Lee was assassi-
nated while driving by an unidentified
shooter in a passing vehicle.

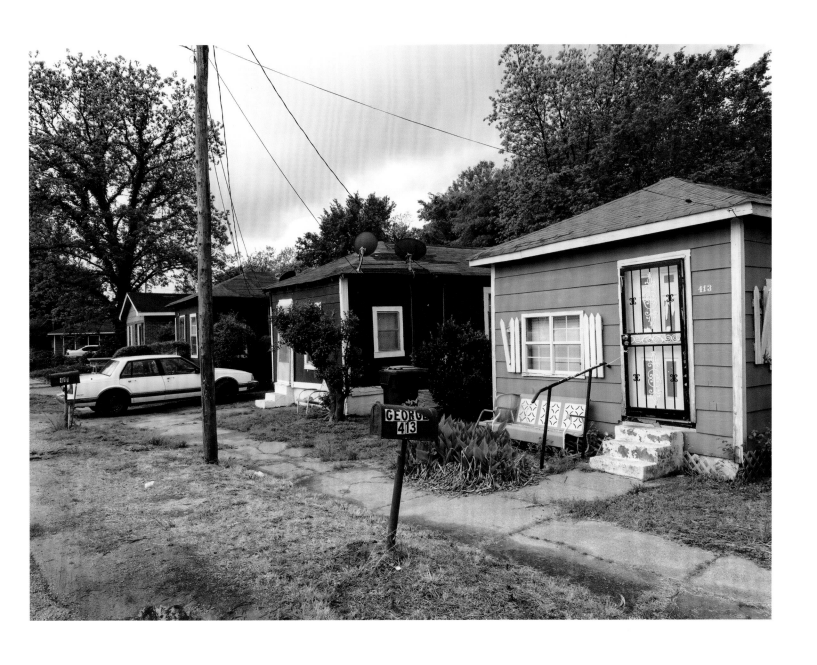

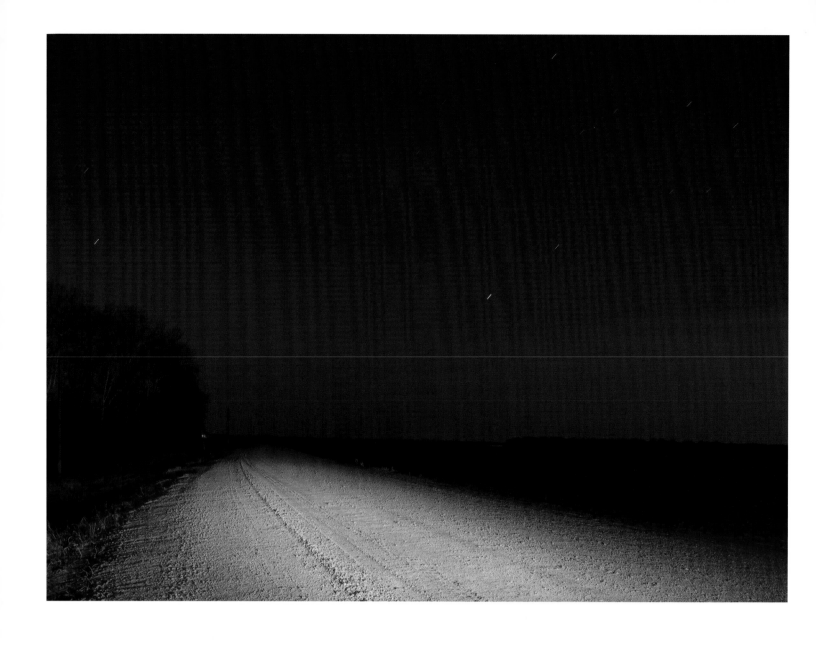

Road, Money, Mississippi, 2018

Throughout the eighteenth and nineteenth centuries, militias of white citizens known as slave patrols or night watches traveled southern roads at night to enforce slave curfews, intimidating enslaved people and issuing violent "justice" in the form of lashings. The patrols continued through Reconstruction and into the civil rights era, when they were used to terrorize Black Americans attempting to register to vote or civil rights activists working to register others.

Road between Greenwood and Money, Mississippi, 2018

These abandoned sharecropper homes located north of Greenwood are on the two-lane highway leading to Money, Mississippi. Greenwood was a major center of the cotton industry prior to the Civil War and a hotbed of voter-registration activity and protest in the 1960s. In 2006, Greenwood elected its first female and first Black American mayor, Sheryl Perkins.

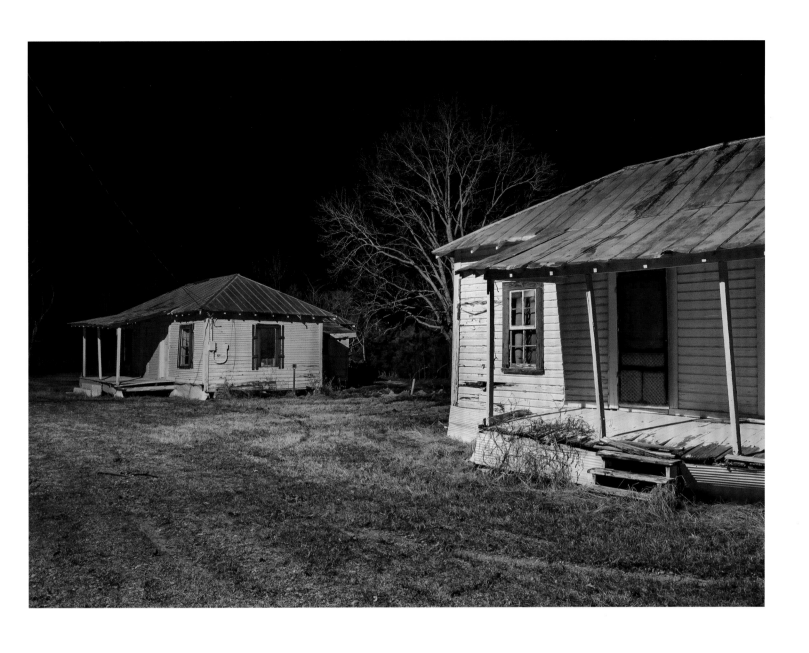

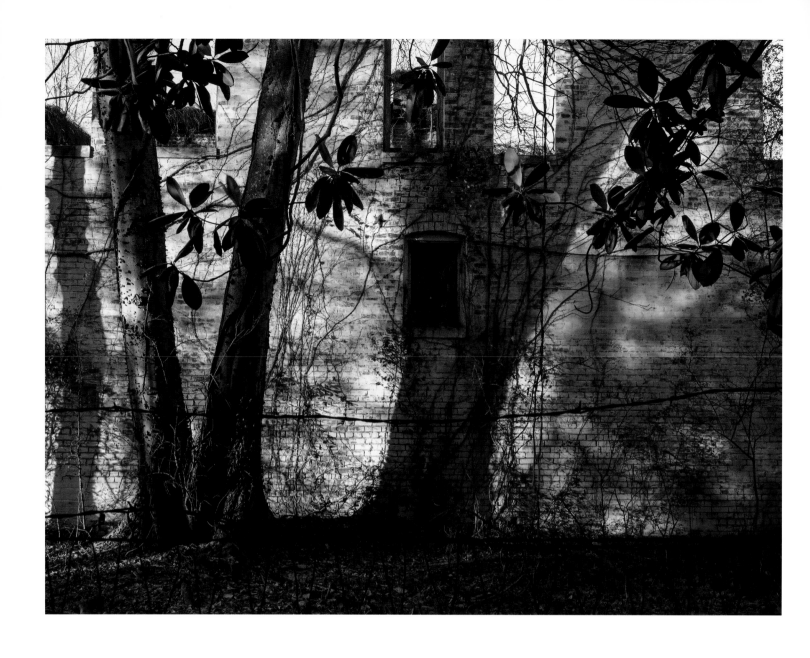

Seed Barn, Drew, Mississippi, 2018

Four days later, Carolyn Bryant's husband, Roy, and Roy's half-brother, J. W. Milam, kidnapped Till from his uncle's home, where he was staying for the summer. The abductors took him to a seed barn in the nearby town of Drew, where he was tortured, mutilated, and murdered. His body was then dumped in the Tallahatchie River with a seventy-five-pound cotton-gin fan tied to his body with barbed wire.

Ruins of Bryant's Grocery, Money, Mississippi, 2018

In August 1955, a fourteen-year-old Black American from Chicago, Illinois, named Emmett Till allegedly wolf-whistled at Carolyn Bryant, a white woman, while buying candy at her husband's store.

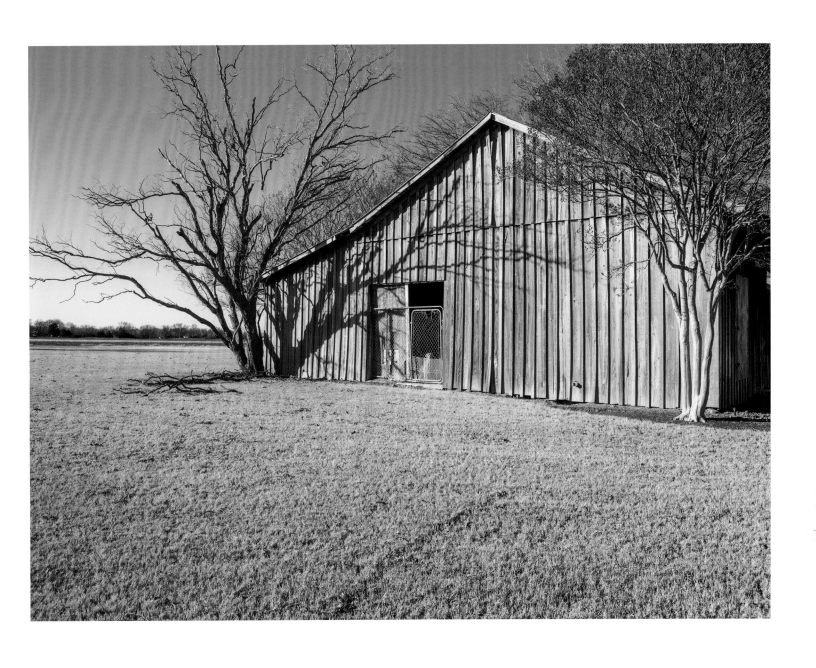

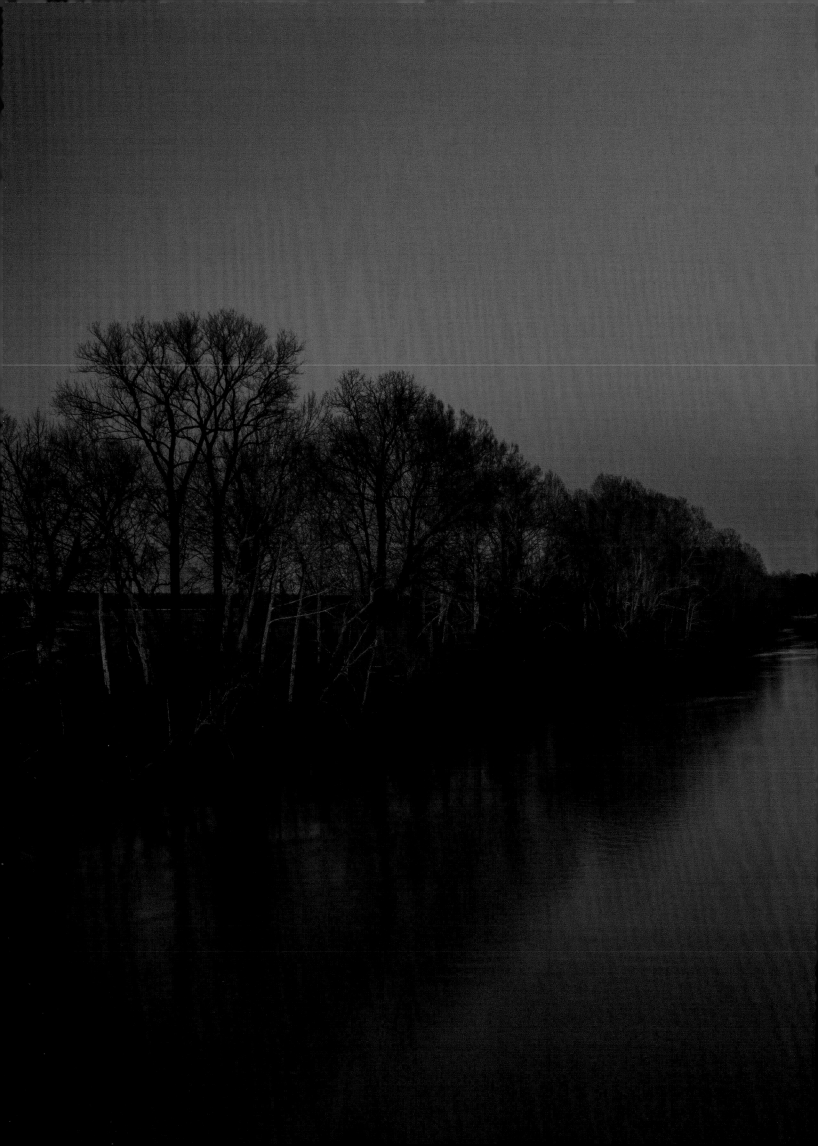

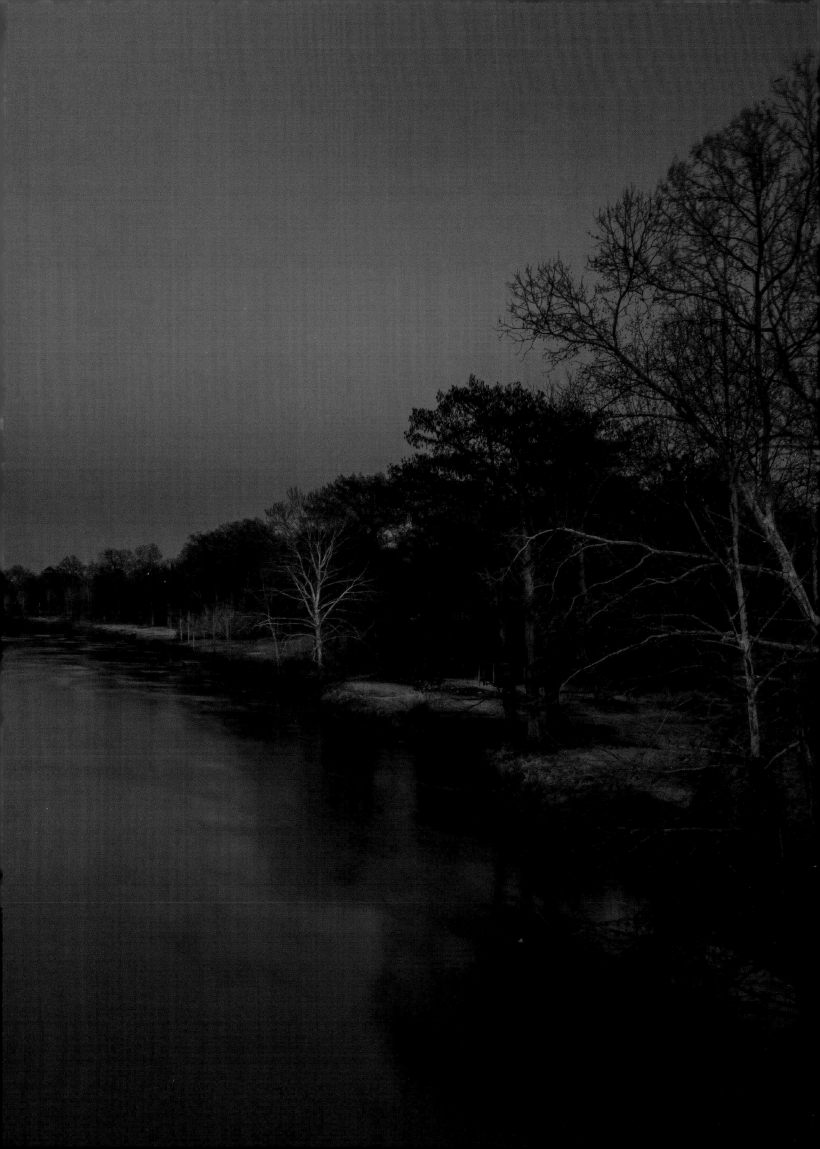

(*previous spread*)
**Tallahatchie River, Greenwood,
Mississippi, 2018**

Emmett Till's body was found upstream
from this spot on the Tallahatchie River.
He was so disfigured that his uncle
could identify him only by a signet ring
on his finger. Till's mother, Mamie, fought
to have her son transported north and
buried near their home in Chicago. The
photographs of her severely disfigured
son in an open casket ran in *Jet* maga-
zine. She told the funeral director,
"Let the people see what I've seen."

**Tallahatchie County Courthouse,
Sumner, Mississippi, 2018**

On the night Emmett Till was abducted
from the home of his uncle, Mose Wright,
J. W. Milam asked Wright, "How old are
you?" "Sixty- four," Wright replied. "Well,"
Milam continued, "if you know any of us
here tonight, then you will never live to
get to be sixty-five." Months later, in a
crowded courtroom, the jury of twelve
white men—all neighbors of the accused
killers—watched the diminutive Mose
Wright stand and lean to point at Milam.
"There he is," Wright said. The jury delib-
erated for one hour and five minutes
before delivering the verdict of not guilty.
"If we hadn't stopped to drink pop,"
one juror said in an interview for the
New York Times, "it wouldn't have taken
that long." Just four months after their
acquittal, Milam and Bryant, protected
by "double jeopardy," were compensated
four thousand dollars to give a tell-all
interview to *Look* magazine. The piece,
titled "The Shocking Story of Approved
Killing in Mississippi," detailed how
the men pistol-whipped Till with their
.45s and then shot him in the head.

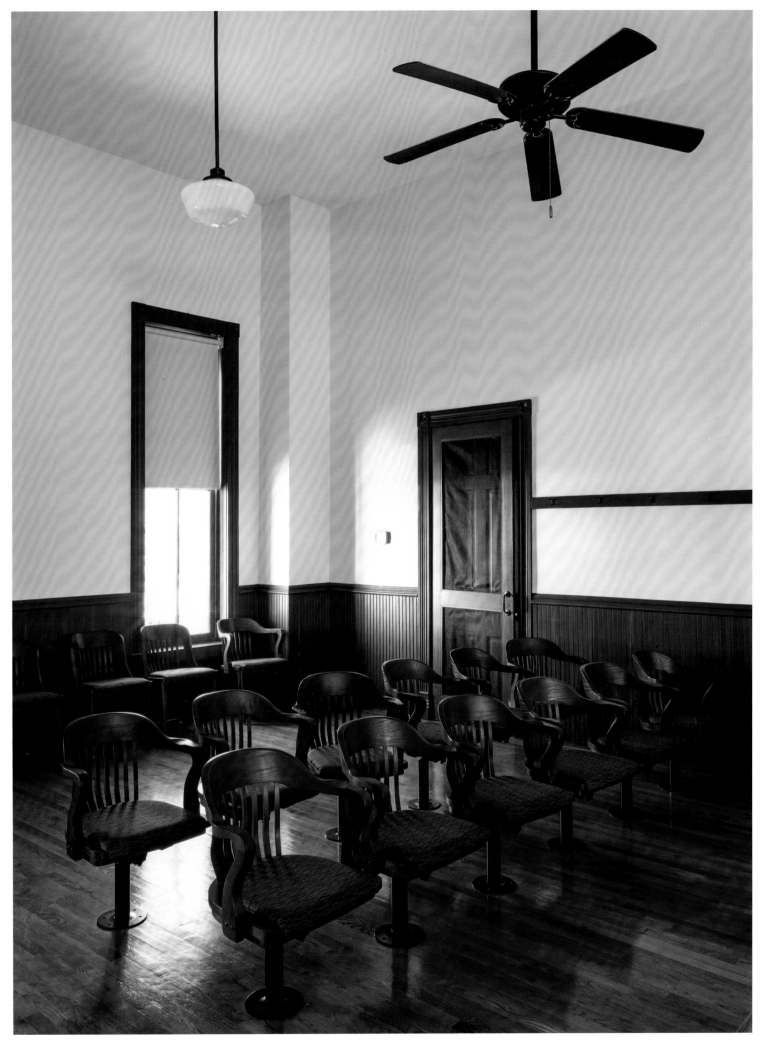

**Historical Marker, Emmett Till
Memorial Project Offices, Sumner,
Mississippi, 2018**

In 2008, after the Emmett Till Memorial
Commission placed a memorial at the
spot where Till's body had been recov-
ered from the Tallahatchie River in 1955,
it was defaced by vandals. Thirty-five
days after the first sign was replaced, the
second was riddled with shotgun pellets.
A bulletproof sign is now in place. A *New
York Times* report from July 26, 2019,
included a photograph of three members
of the University of Mississippi chapter
of Kappa Alpha fraternity posing with
guns in front of one of the signs. Kappa
Alpha claims the Confederate general
Robert E. Lee as its "spiritual founder."

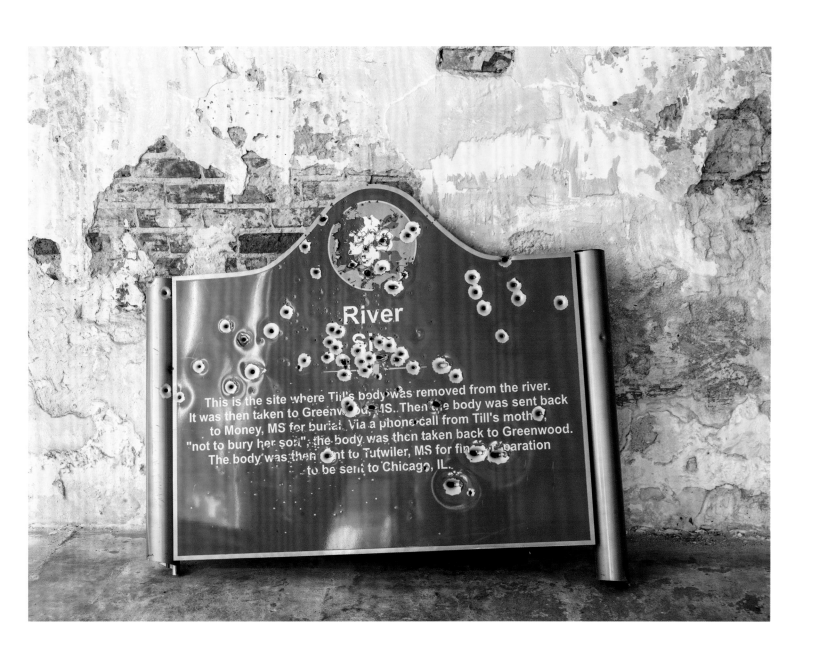

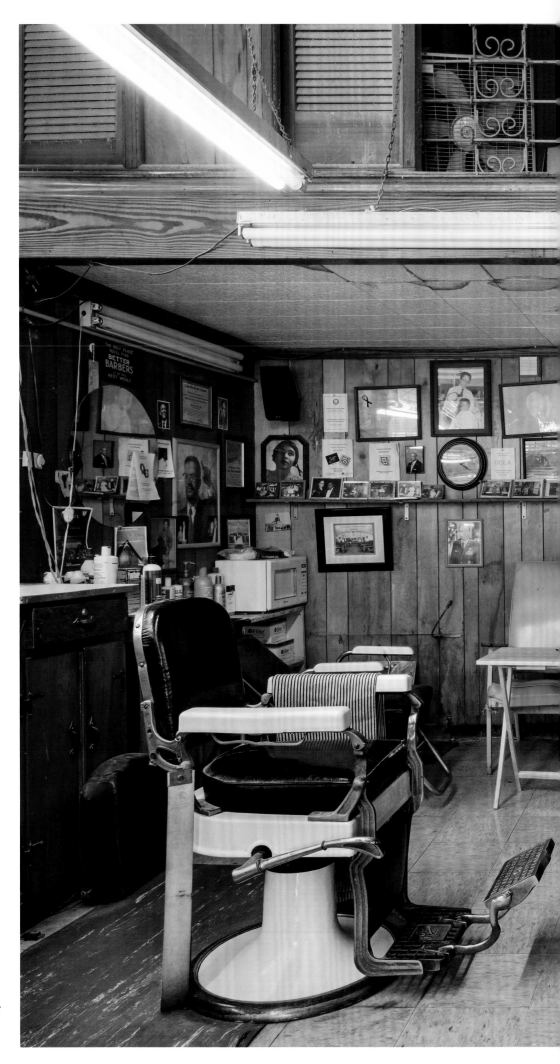

Malden Bros. Barbershop, Montgomery, Alabama, 2017

Located in the Ben Moore Hotel, the Malden Bros. Barbershop, where Dr. Martin Luther King Jr. got haircuts, played an important role in the Montgomery Bus Boycott. Dr. King and other leaders would meet there to discuss strategy during the campaign.

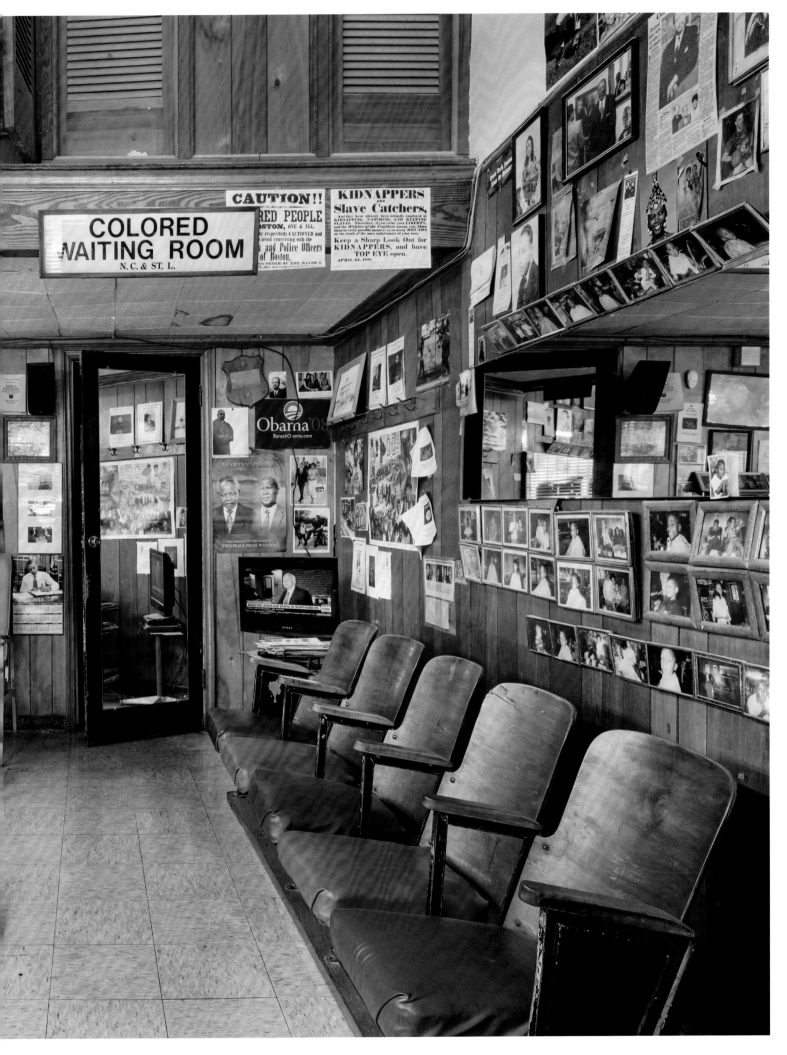

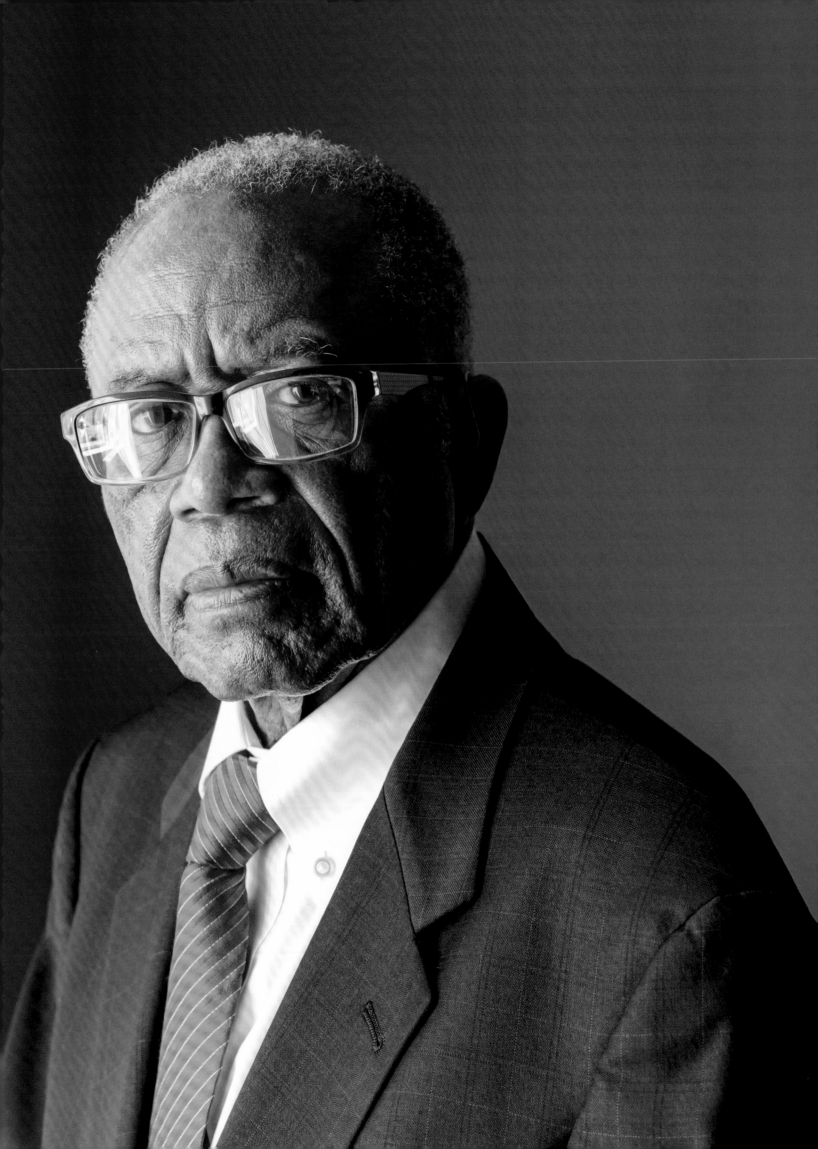

Fred Gray, Tuskegee, Alabama, 2017

When he was twenty-five, the attorney Fred Gray helped organize the Montgomery Bus Boycott, and soon afterward began serving as legal counsel to Dr. Martin Luther King Jr. Early in his career, Gray defended Claudette Colvin, one of the early resisters to the "back of the bus" rule, as well as Rosa Parks, eventually suing to integrate buses in Montgomery, Alabama. In *Gomillion v. Lightfoot* in 1960, Gray argued for the redistricting and reapportionment of legislatures throughout the United States. He is also known for representing the victims of the infamous Tuskegee Study of Untreated Syphilis.

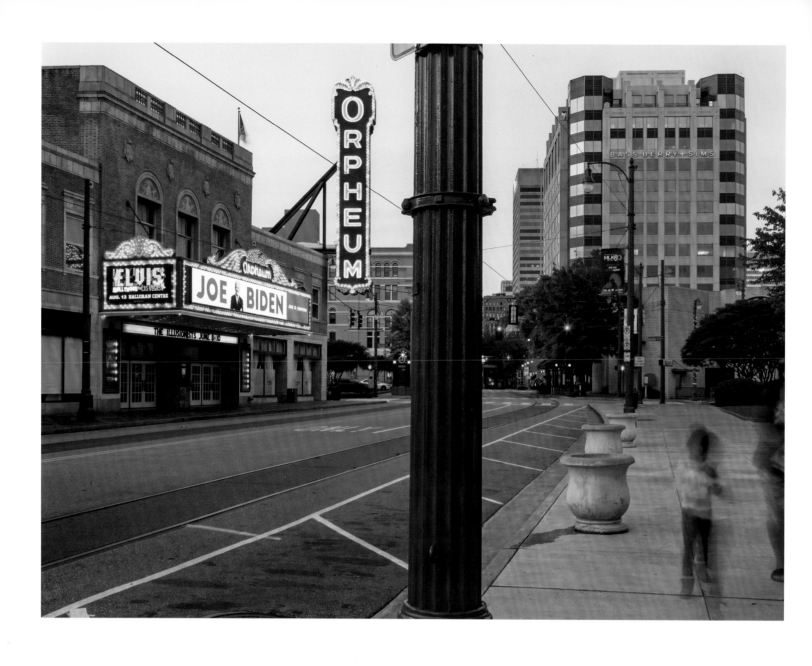

Orpheum Theatre, Memphis, Tennessee, 2018

The Orpheum Theatre in downtown Memphis, Tennessee, first opened in 1928. It has preserved its separate entrances and lobbies for white and black moviegoers as a potent historical reminder of the indignities imposed on Black American citizens during segregation.

(*following spread*)
Greyhound Bus Station, Montgomery, Alabama, 2018

The Freedom Riders were a group of black and white activists fighting to desegregate "whites-only" bus terminals. On May 20, 1961, a violent attack on the group by a white mob of men, women, and children wielding bats and clubs outside the Montgomery Greyhound Bus Station drew widespread attention to the movement and the violent reprisals it faced. Among those beaten were members of the press and several Riders, including future Congressman John Lewis.

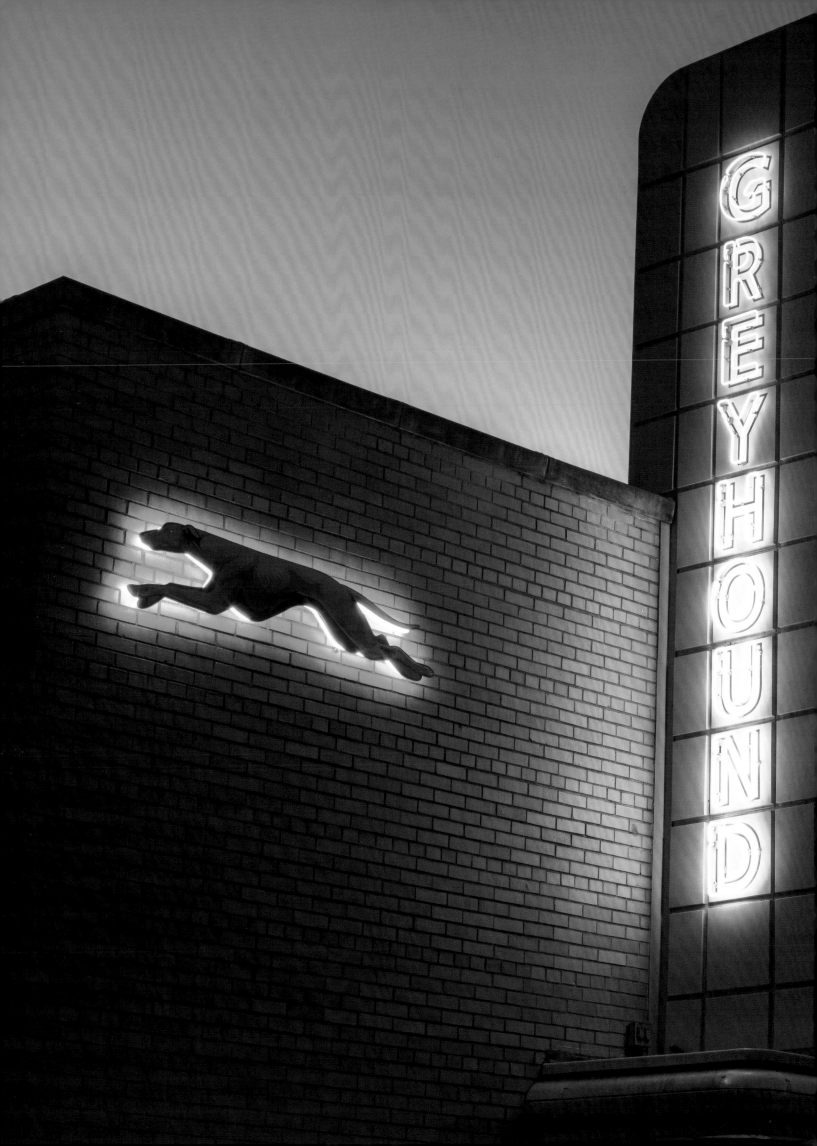

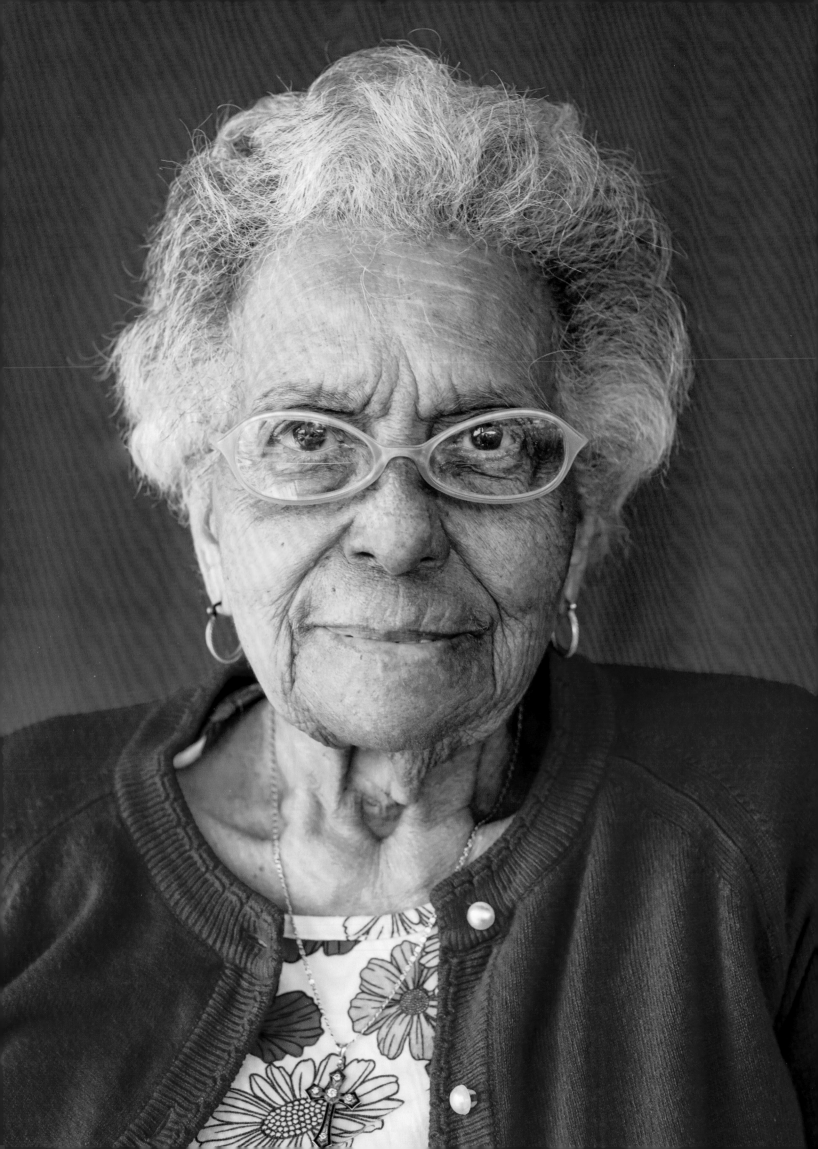

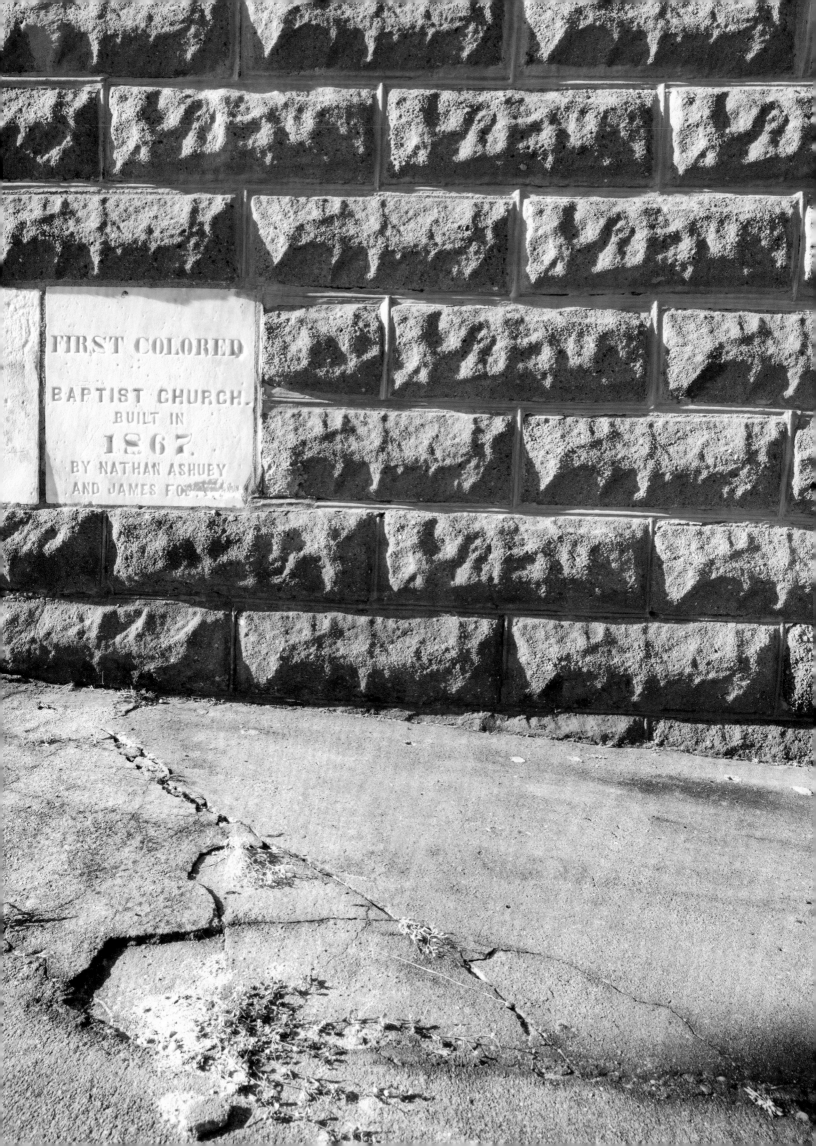

(*previous spread, right*)
**First Baptist Church,
Montgomery, Alabama, 2017**

Built by formerly enslaved people in 1867,
the First Baptist Church in Montgomery,
Alabama, was led by Reverend Ralph
Abernathy during the civil rights move-
ment, serving as an important center of
operations during the Montgomery Bus
Boycott and other actions. During the
attack on the Freedom Riders in May
1961, Riders and their supporters sought
refuge in the church. By nightfall, 1,500
people had congregated inside as a white
supremacist mob surrounded the build-
ing. Threats, including calls to burn the
church with all inside, continued through
the night. The occupants, among them
Dr. Martin Luther King Jr., the Reverend
Abernathy, and other boycott leaders,
were held hostage there until martial law
was declared at the direction of US Attor-
ney General Robert F. Kennedy. Around
1 a.m., with National Guard troops in
place and the mob dispersed, those
inside the church were released.

(*previous spread, left*)
**Vera Harris, Montgomery,
Alabama, 2018**

Vera Harris, along with her hus-
band, Dr. Richard Harris, and their
family, lived a few doors down from
Dr. Martin Luther King Jr. and his fam-
ily in Montgomery. When Freedom
Riders were attacked by a mob at a
nearby Greyhound Bus station in 1961,
the couple welcomed and sheltered
the beleaguered activists. Mrs. Harris
passed away on September 10, 2019.

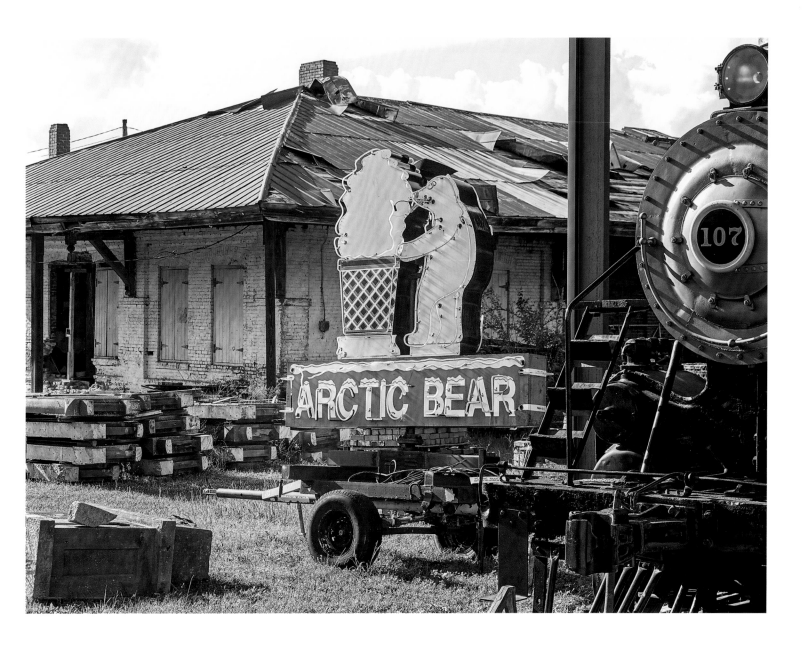

**Former Train Station,
Albany, Georgia, 2019**

In 1961, young fieldworkers for SNCC (the Student Nonviolent Coordinating Committee) and members of Dr. Martin Luther King Jr.'s SCLC (the Southern Christian Leadership Conference) arrived in Albany, Georgia, to agitate for voting access and desegregation alongside local leaders. Their efforts became known as the Albany Movement. The Albany Movement revealed significant differences in strategy between the more centralized SCLC and the more grassroots SNCC. The Arctic Bear sign is now in the collection of the Thronateeska Heritage Center at the former Albany train station where, in December 1961, eight Freedom Riders (four white and four black) along with three local students were arrested at the station by Sheriff Laurie Pritchett, who feared the waiting crowd "could get out of hand at any time."

Main Street, Clarksdale, Mississippi, 2018

In 1951, residents in Clarksdale, Mississippi formed a local chapter of the NAACP. In 1961, after a decade of steady growth and activity, the group began a boycott of local businesses to protest the barring of black students from the annual Christmas pageant. White residents, assisted by local police, began a campaign of violence to end the boycott, which nevertheless continued into 1963. Violence escalated as civil rights workers began entering Clarksdale to support local efforts and register voters.

Dynamite Hill, Birmingham, Alabama, 2018

Birmingham, Alabama, defied federally mandated zoning laws that banned segregation in the 1940s and '50s. But as Jim Crow laws weakened, upwardly mobile Black Americans began moving into the formerly all-white neighborhood of College Hills. By the middle of 1949, the Ku Klux Klan (or KKK, seen as the last defense by reactionary white citizens) had bombed so many Black American homes there that the once-bucolic area became known as Dynamite Hill. The former home of the NAACP attorney Arthur Shores is visible on the left side of this image.

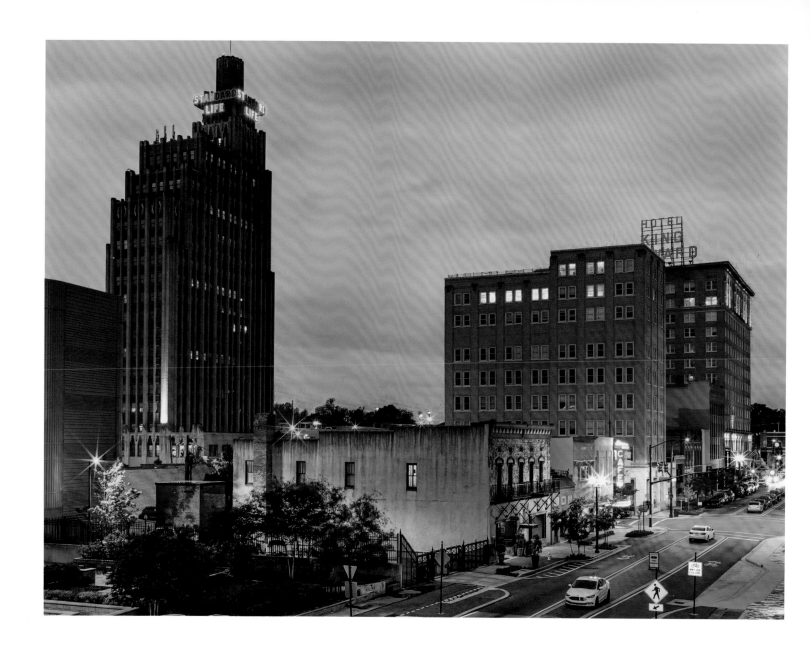

**Myrlie and Medgar Evers Family Home,
Jackson, Mississippi, 2018**

**Capitol Street, Jackson,
Mississippi, 2018**

Jackson, Mississippi, was the adopted
home of the World War II veteran and
NAACP field secretary Medgar Evers.
Evers, who led voter registration drives
and economic boycotts of businesses on
Capitol Street, was shot and killed in his
driveway on June 12, 1963, hours after
President Kennedy's landmark address
on civil rights.

As a veteran, Evers was buried with full
military honors at Arlington National
Cemetery before a crowd of some three-
thousand mourners. Evers's assassin was
Byron De La Beckwith, a member of the
racist White Citizens' Council and later,
the KKK. De La Beckwith was released
when all-white juries failed to reach ver-
dicts in two trials for Evers's murder in
1964. In 1994, however, he was finally
convicted in a state trial brought with
new evidence.

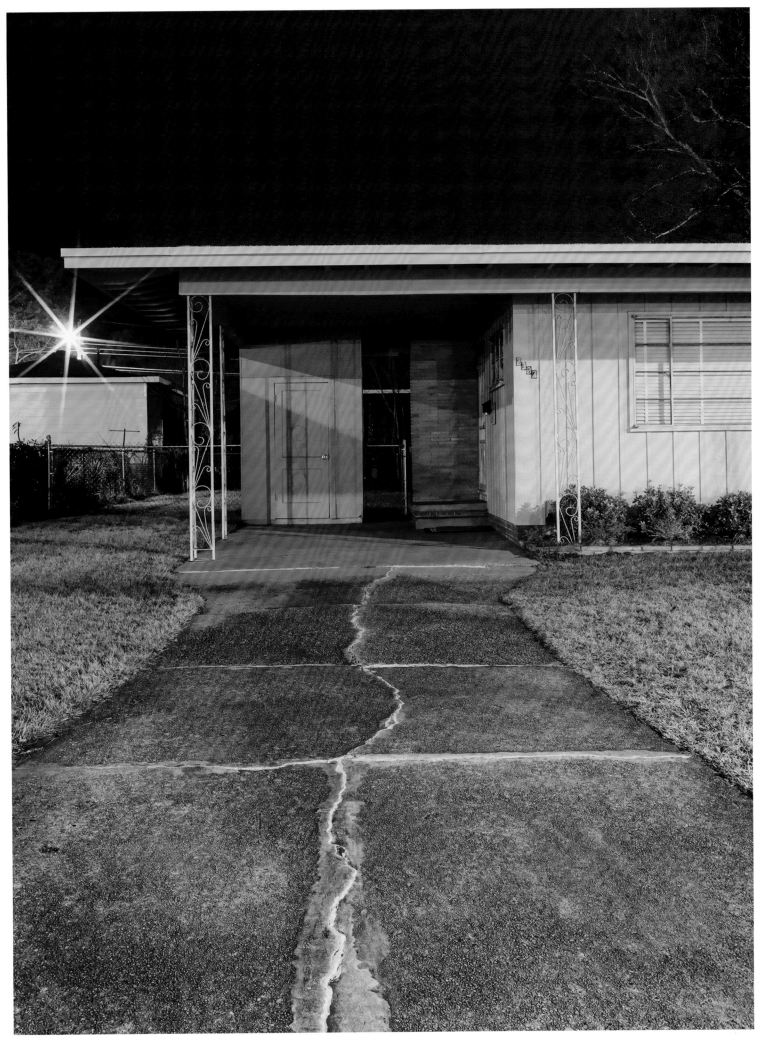

**The Leesburg Stockade,
Leesburg, Georgia, 2019**

In July 1963, thirty-three girls, some as
young as twelve, were arrested after a
peaceful march to protest segregation
at a movie theater in Americus, Geor-
gia. They were transported to nearby
Leesburg and held forty-five days in a
Civil War–era stockade with concrete
floors and one toilet. Neither they nor
their families knew where they were. The
photographer Danny Lyon, working on
behalf of SNCC, managed to photograph
the imprisoned girls. Publication of the
images helped lead to their release.

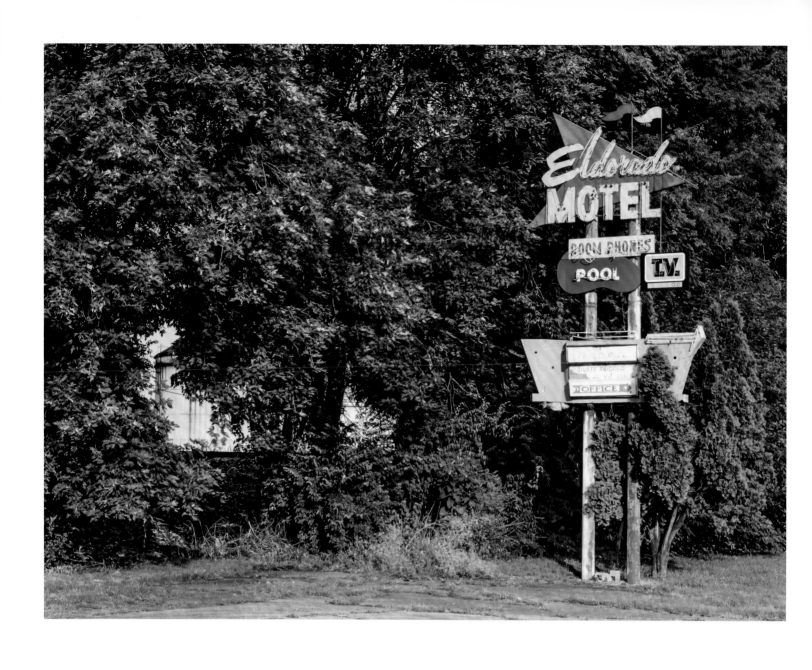

**Eldorado Motel, Nashville,
Tennessee, 2018**

This sign is the last vestige of the Eldo-
rado Motel, one of the few places in
Nashville, Tennessee, where Black
American travelers could rent a room
during segregation. Dr. Martin Luther
King Jr. and entertainer-activist Harry
Belafonte stayed there in 1961 while vis-
iting to attend an SCLC-sponsored con-
cert at the Ryman Auditorium. The Eldo-
rado was literally "across the tracks."

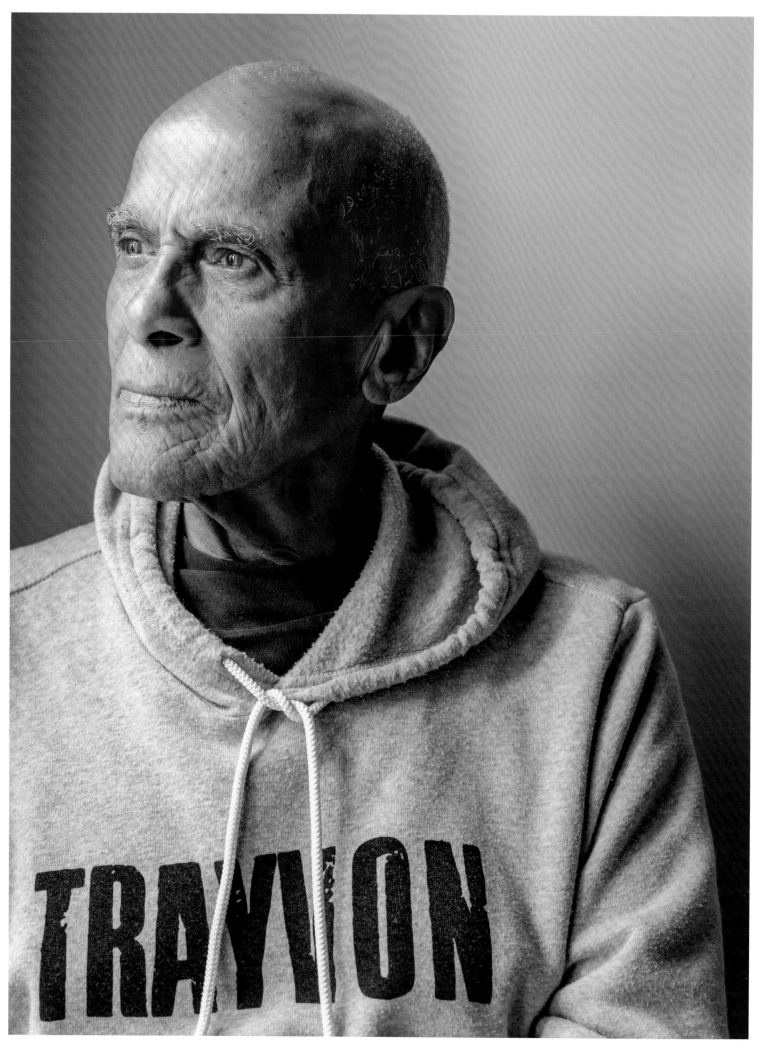

**Harry Belafonte,
New York, New York, 2018**

Harry Belafonte was a key fundraiser and adviser to Dr. Martin Luther King Jr., and spent hundreds of thousands of dollars to bail out imprisoned activists and protesters throughout the 1950s and 1960s. Belafonte marched in his first protest at age twenty-four. He cites Paul Robeson, an earlier black performer and activist, as a major influence. Belafonte quotes Robeson: "Artists are the gatekeepers of truth, the moral compass of the universe." Belafonte remains active in the movement, and in 2018 appeared as an aging civil rights leader in Spike Lee's film *BlacKkKlansman*. When this photograph was made, Belafonte said, "Trayvon was my son … this sweatshirt says America."

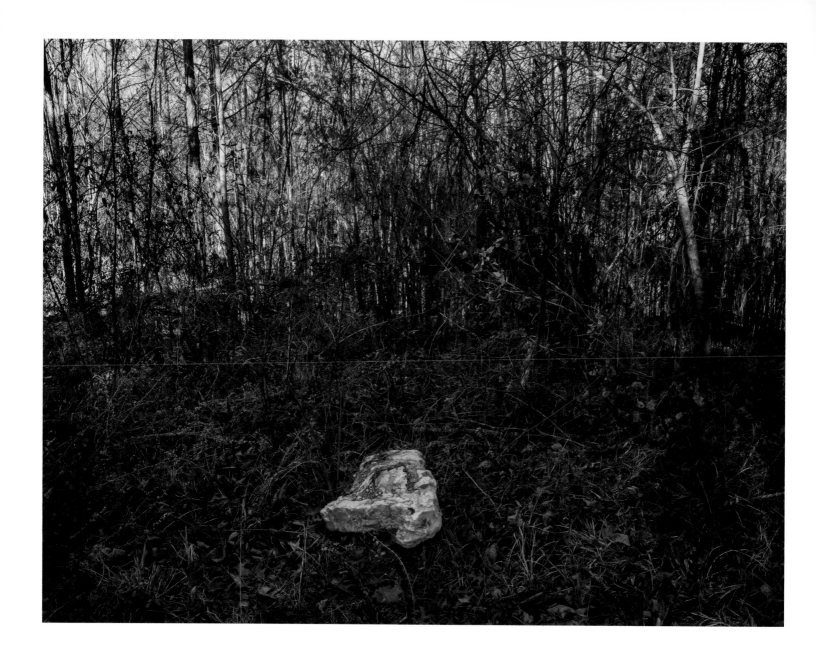

**Murder Site, Neshoba County,
Mississippi, 2018**

The 1964 Mississippi Freedom Summer project was a ten-week voter registration push organized by a coalition group called the Council of Federated Organizations (COFO). The coalition included the SCLC, SNCC, the Congress of Racial Equality (CORE), and the NAACP, and involved nearly a thousand college-student volunteers who traveled to the region to educate and register voters. At the start of the campaign, two CORE student-activists—Andrew Goodman and Michael Schwerner—together with James Chaney, a local organizer, traveled to Neshoba County, Mississippi, to investigate the bombing of a black church. Arrested by local authorities, they were released, but disappeared soon after.

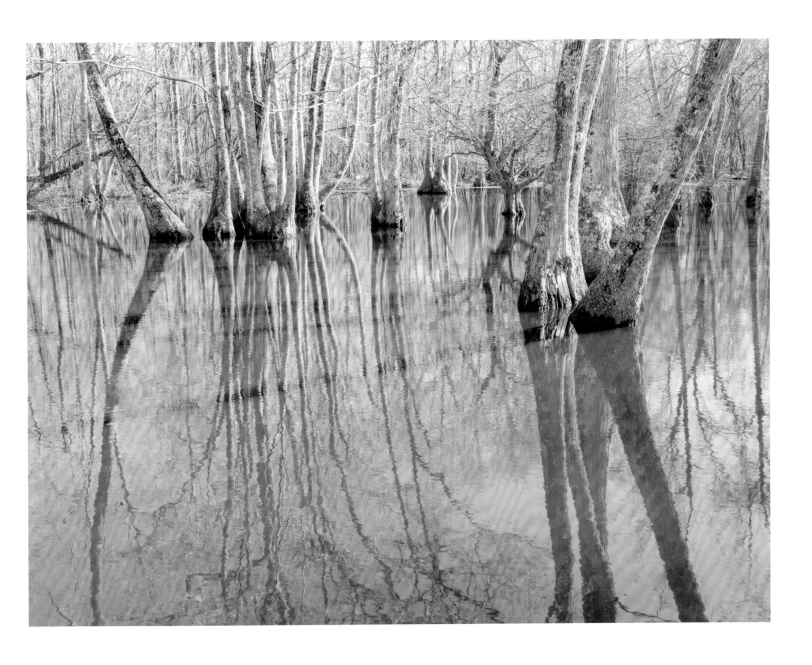

**Site Near the Earthen-Dam
Burial Location, Bogue Chitto,
Mississippi, 2018**

Two days after the three Freedom Summer workers were reported missing, their blue 1953 Ford station wagon was found submerged in the Bogue Chitto swamp. Forty-two days after that, their bodies were found buried in a newly constructed earthen dam nearby. James Chaney, the only Black American in the group, had been brutally beaten. In the years that followed, the state did not prosecute anyone for murder. Decades later the case was reopened, resulting in the prosecution of former Klan organizer Edgar Ray Killen for manslaughter. The Klan, under orders from Samuel Bowers, the charismatic Imperial Wizard of the most violent and secretive division of the KKK, the Mississippi White Knights, was ultimately found responsible. Bowers served six years in federal prison for the killings. He died in prison in 2006, having been convicted in the later killing of Vernon Dahmer at his home in Hattiesburg in 1966, a reprisal for Dahmer's work registering voters. In what was considered an implicit response to the area's civil rights history, Ronald Reagan gave his first speech as the Republican presidential nominee in 1980 at the Neshoba County Fairgrounds.

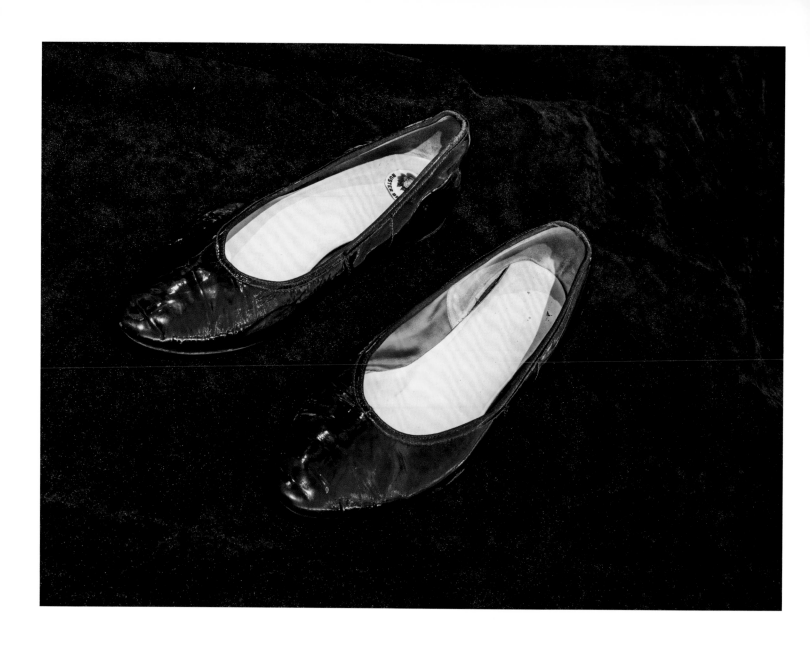

Buster Brown Shoes Worn by Denise McNair When Murdered, Birmingham Civil Rights Institute, Montgomery, Alabama, 2018

On September 14, 1963, by order of Exalted Klan Cyclops Robert Thomas, Robert Chambliss, a well-known bomb-maker and Klansman, purchased 140 sticks of dynamite from a sympathetic explosives dealer. The following morning, an explosion at the Sixteenth Street Baptist Church killed fourteen-year-old Denise McNair and three other black teenage girls, and injured twenty-two other people. That same day, two young black boys were killed in separate, unrelated shootings by a white citizen and police officer a few hours after the bombing. It wasn't until more than ten years later, in 1977, that Chambliss was convicted for the bombing.

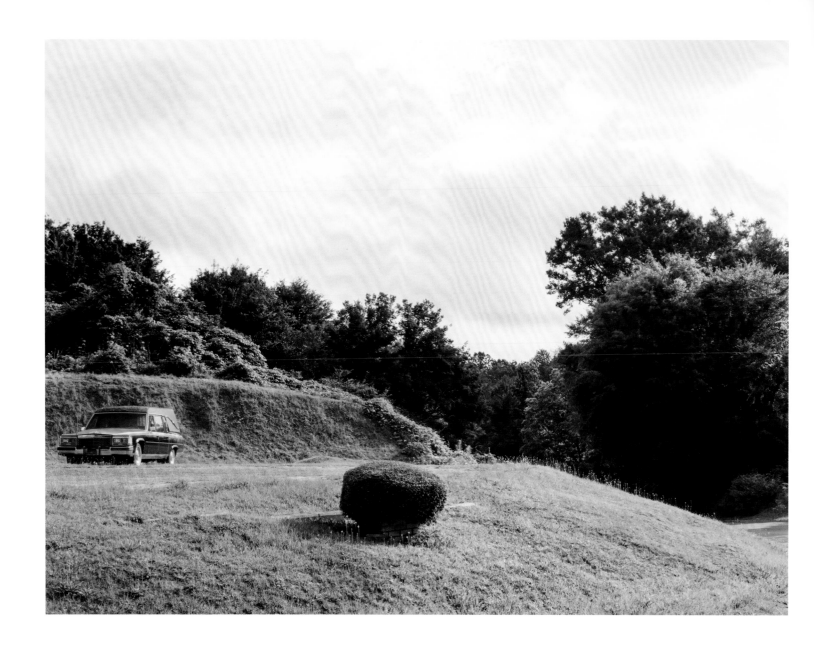

**Jimmie Lee Jackson Murder Site,
Marion, Alabama, 2017**

In 1965, the Reverend James Orange, a Black American SCLC organizer, was arrested for "disorderly conduct and contributing to the delinquency of minors" and held in the Perry County Jail in Marion. Fearing he would be lynched, his supporters gathered at the adjacent Zion United Methodist Church to pray and organize a peaceful march. As soon as they left the church, the demonstrators were attacked by Alabama state troopers. During the melee, a trooper shot and killed Jimmie Lee Jackson, a black Vietnam veteran who had taken refuge at Mack's Cafe, located directly behind the church and jail. He had been attempting to shield his mother and grandfather from the violence. His murder led James Bevel, an SCLC organizer, to call for a march from Selma to Montgomery, thus becoming the spark for the famous processions. In 2010, Alabama State Trooper James Bonard Fowler was indicted and pleaded guilty to misdemeanor manslaughter. He was sentenced to six months in prison.

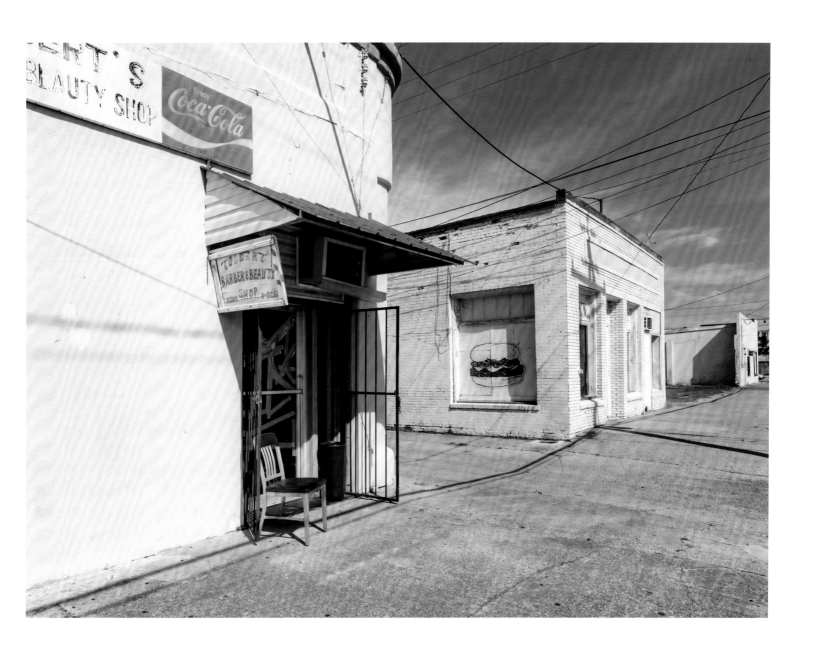

**Former Location of the Silver Moon
Cafe, Selma, Alabama, 2017**

On March 9, 1965, James Reeb, a Unitarian minister from Boston who had come to Alabama to participate in the march to Selma, went to the Silver Moon Cafe with several members of the clergy, including two other white Unitarian ministers, to discuss plans for the protest. When he and his two coreligionists left the restaurant, they were attacked by a group of club-wielding white men. Reeb was struck in the head and died from the injury a few days later. Up to this point, little attention had been paid to the events brewing in Selma, including the death of Jimmie Lee Jackson a few weeks earlier. The death of a white man, however, brought national attention to the situation. Reeb's death became a symbol of the racial injustices present in the region and supplied enough political cover to move President Johnson and Congress to act on voting rights. A few months later, the Voting Rights Act of 1965 was signed into law.

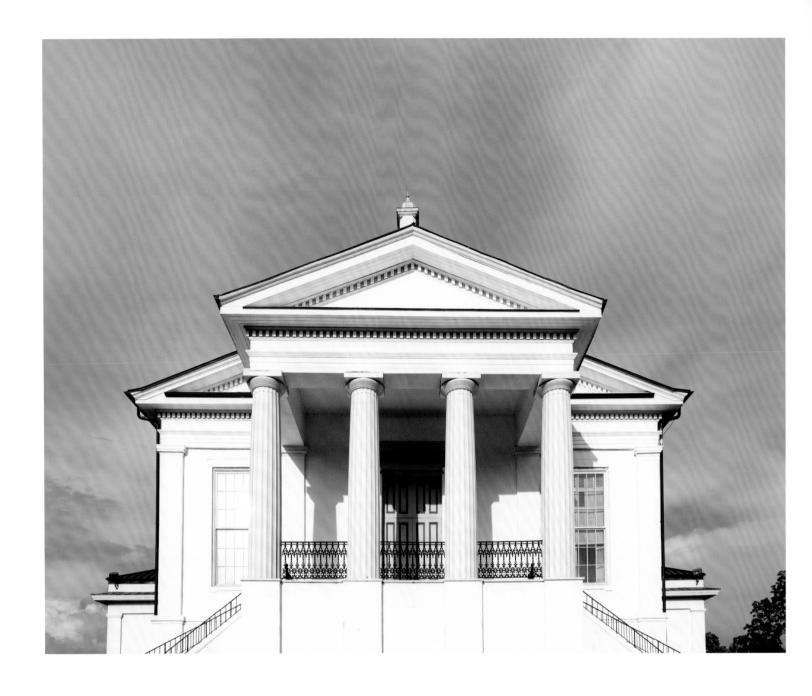

**Lowndes County Courthouse,
Hayneville, Alabama, 2017**

Two landmark trials of the civil rights
movement took place at the Lown-
des County Courthouse in Hayneville
in 1965: that of the three Klansmen
responsible for killing the civil rights
activist Viola Liuzzo, and that of Tom
L. Coleman, the unpaid special deputy
responsible for killing the Reverend Jon-
athan Daniels, an Episcopal seminarian
and voting rights activist. Coleman was
acquitted of manslaughter charges. In
both cases, decisions were rendered by
all-white juries.

**Memorial to Viola Liuzzo, Lowndes
County, Alabama, 2018**

In 1965, Viola Liuzzo, a thirty-nine-year-
old mother of five from Detroit, Michi-
gan, was murdered by Klansmen who
shot at her car as she drove through
Lowndes County, Alabama, on her way
back from dropping fellow activists at
the Montgomery Airport. Two weeks
after her death, a cross was burned
on the Liuzzo family's lawn in Detroit.

Three men, each a member of the
KKK, were acquitted of state charges
despite eyewitness testimony by Gary
Rowe, an FBI informant present in
the vehicle from which the shots were
fired. Later in 1965, the three Klans-
men were successfully prosecuted on
federal charges of conspiring to violate
Mrs. Liuzzo's civil rights.

**Storefront Church, Marks,
Mississippi, 2018**

In 1967, shaken by the poverty he wit-
nessed in Marks, Mississippi, Dr. Martin
Luther King Jr. called for a march on
Washington, DC. The Poor People's
Campaign set off from Marks a year
later, after Dr. King's murder. Arriving
in Washington, an estimated three
thousand people set up camp on the
Washington Mall to call attention to
poverty in America. In 2017, the Rever-
end Liz Theoharis, a biblical scholar and
Presbyterian minister, and the Reverend
William Barber II, the former head of
the North Carolina NAACP, organized
the Poor People's Campaign: A National
Call for a Moral Revival, to build on and
revive the original campaign.

Clayborn Temple, Memphis, Tennessee, 2018

On February 1, 1968, the garbage collectors Echol Cole and Robert Walker were crushed to death by a malfunctioning truck. Ten days later, some seven hundred workers attended a union meeting to address their mistreatment, and on February 12, 1968, the Memphis Sanitation Workers' Strike began. Strikers marched each day from Clayborn Temple to Memphis City Hall, many carrying placards that read "I Am a Man." All means of negotiation and attempts to compromise were met with fierce, violent resistance. The strike came to a head when Dr. Martin Luther King Jr. joined efforts with the strikers and their supporters. The strike officially ended on April 16, 1968, twelve days after Dr. King's assassination. Today, students from the Stax Music Academy practice at the temple. The academy draws on the legacy of Stax Records, using music to inspire and teach students a variety of life skills.

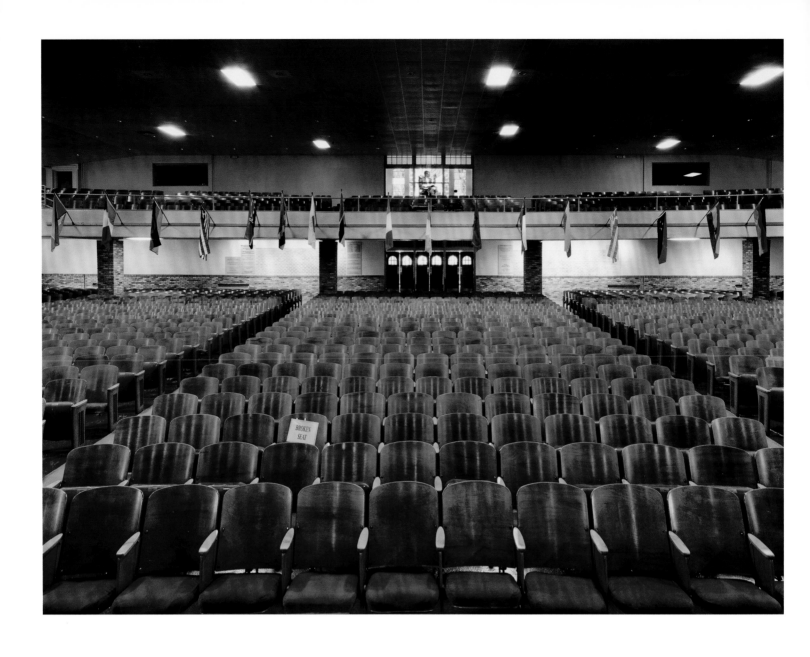

**Views from the Speaker's Podium,
Mason Temple, Memphis,
Tennessee, 2018**

On April 3, 1968, Dr. Martin Luther King
Jr. spoke at the Mason Temple in Mem-
phis in support of the city's striking san-
itation workers. It was his final speech;
he was assassinated the following day.

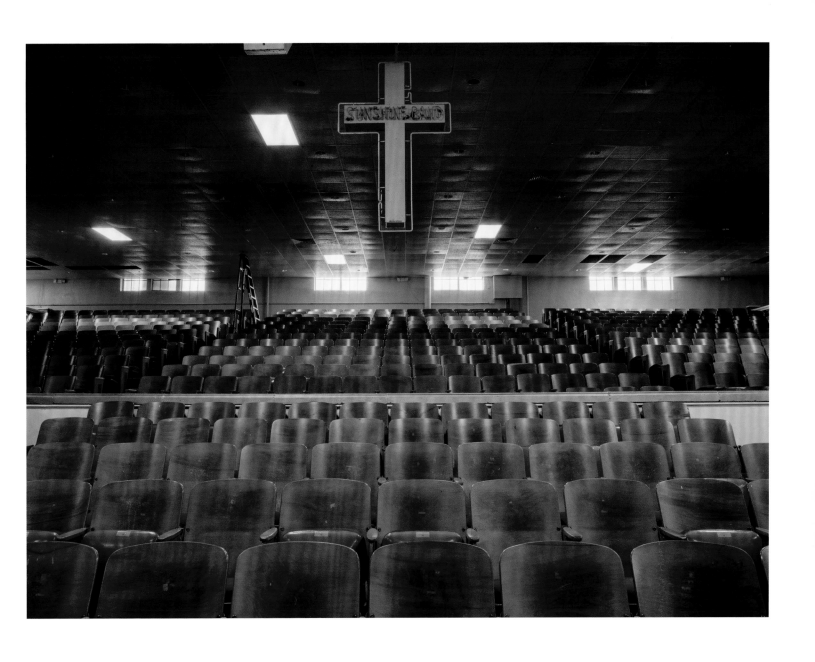

Wallpaper in the Room Where James Earl Ray Stayed, National Civil Rights Museum, Memphis, Tennessee, 2018

James Earl Ray, convicted of murdering Dr. King, stayed in this boardinghouse room across from the Lorraine Motel on April 4, 1968, the day the legendary civil rights leader was assassinated. The National Civil Rights Museum exhibition cites lingering questions about Dr. King's murder, and does not support the theory of a lone gunman.

Hallway between Rooms 307 and 306 and the Balcony Exit, Lorraine Motel, National Civil Rights Museum, Memphis, Tennessee, 2018

Dr. Martin Luther King Jr. was fatally shot on the balcony of the Lorraine Motel on April 4, 1968. Dr. King was staying in room 306 while his aides were in room 307.

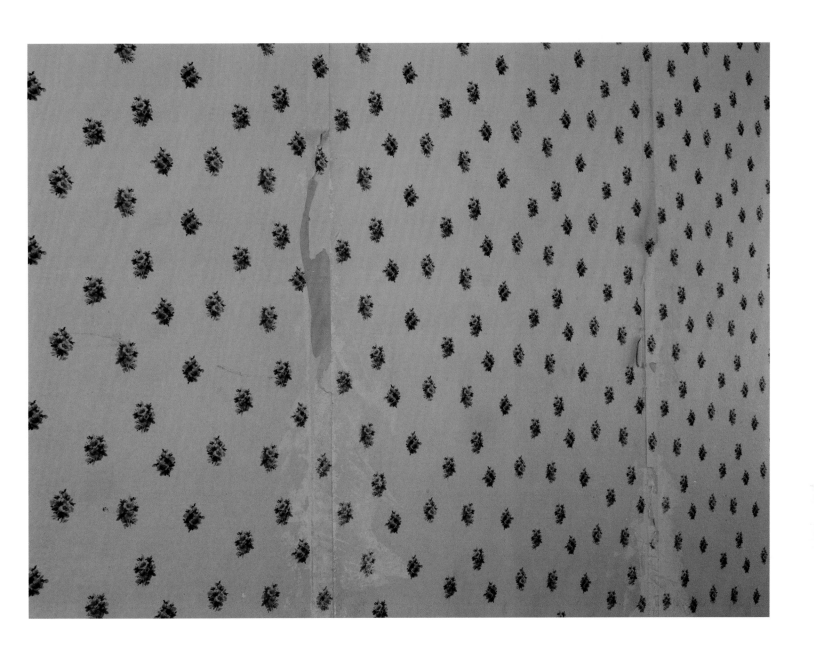

Bullet Holes, Alexander Hall, Jackson State College, Jackson, Mississippi, 2018

On May 14, 1970, ten days after four white students were killed by National Guard troops at Kent State University in Ohio, police fatally shot two black students on the campus of Jackson State College in Mississippi. A report from the President's Commission on Campus Unrest said police fired more than 150 rounds. An FBI investigation revealed that about four hundred bullets or pieces of buckshot had been fired into a women's dormitory, Alexander Hall. The shooters claimed there was a sniper in the dorm, but investigators found "insufficient evidence" of this. The two young men killed were Phillip L. Gibbs, a junior at Jackson State and the father of an eighteen-month-old infant, and James Earl Green, a high school senior.

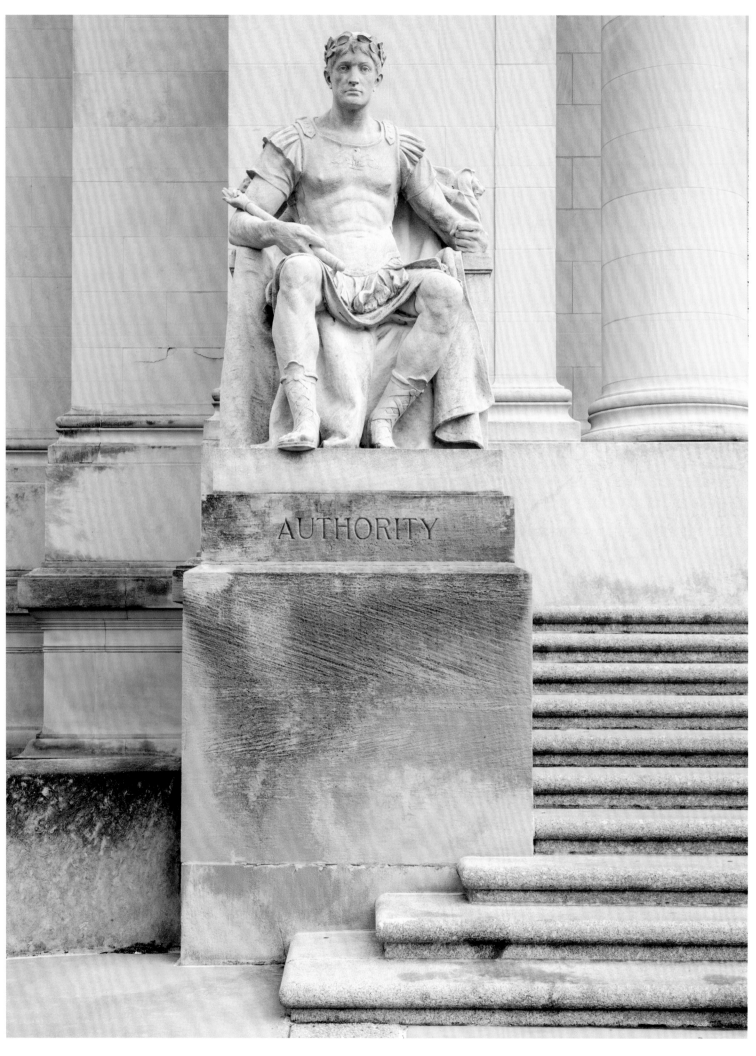

Authority, Shelby County Courthouse, Memphis, Tennessee, 2019

The 1965 Voting Rights Act (VRA) was designed to prohibit state and local governments from passing laws or enacting policies that use race to undermine US citizens' access to the ballot box. Under the act, nine states, based on their histories of discrimination in voting, were required to obtain federal approval to pass or change any election or voting laws. In 2013, the Supreme Court removed a provision in section 4 of the VRA mandating "preclearance," or federal oversight of changes to voting legislation. Since the Court's decision, states have enacted new discriminatory voting laws, such as strict voter ID requirements and other additional burdens to registration, including voter roll purges as well as cutbacks to polling stations, early voting, and absentee voting.

PART II
REDEMPTION

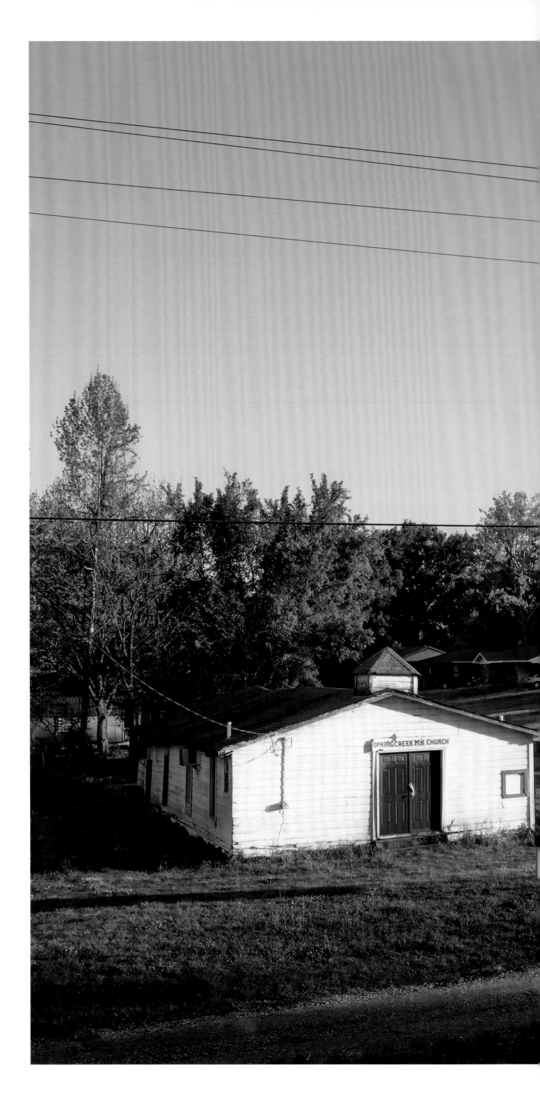

**Spring Street Baptist Church, Route 70,
Screeton, Arkansas, 2018**

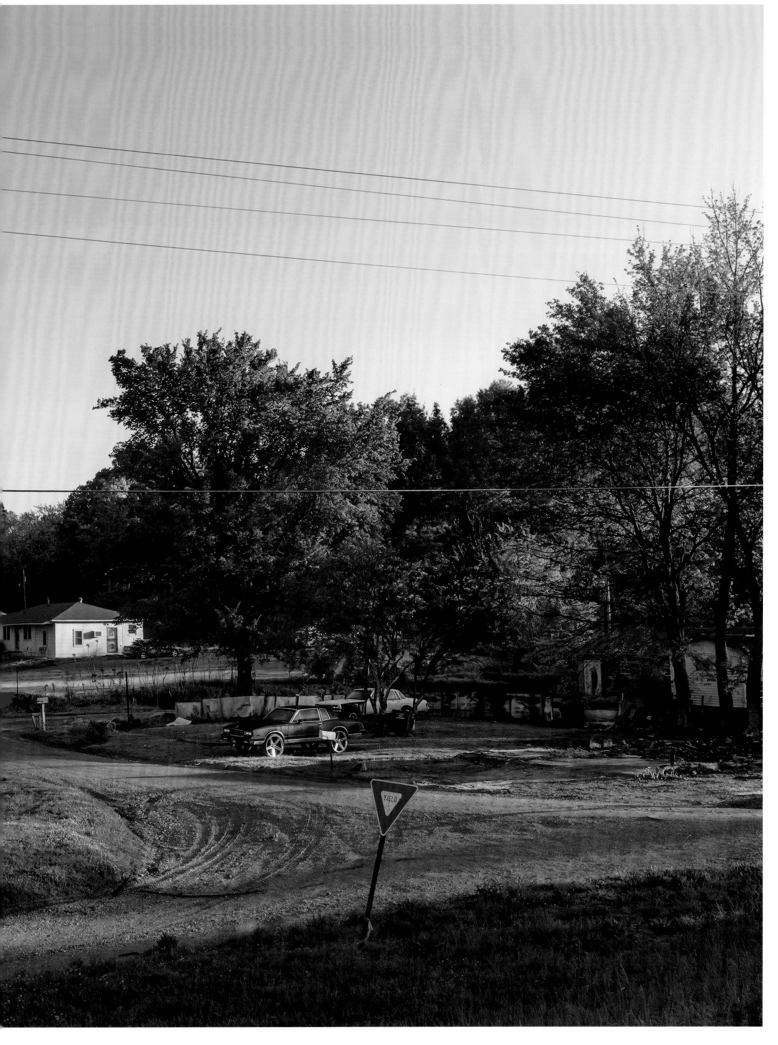

*Dry bones, listen to what the Lord
is saying to you, I, the Lord God, will put
breath in you, and once again you will
live. I will wrap you with muscles and skin
and breathe life into you.*

(Ezekiel 37:4-6)

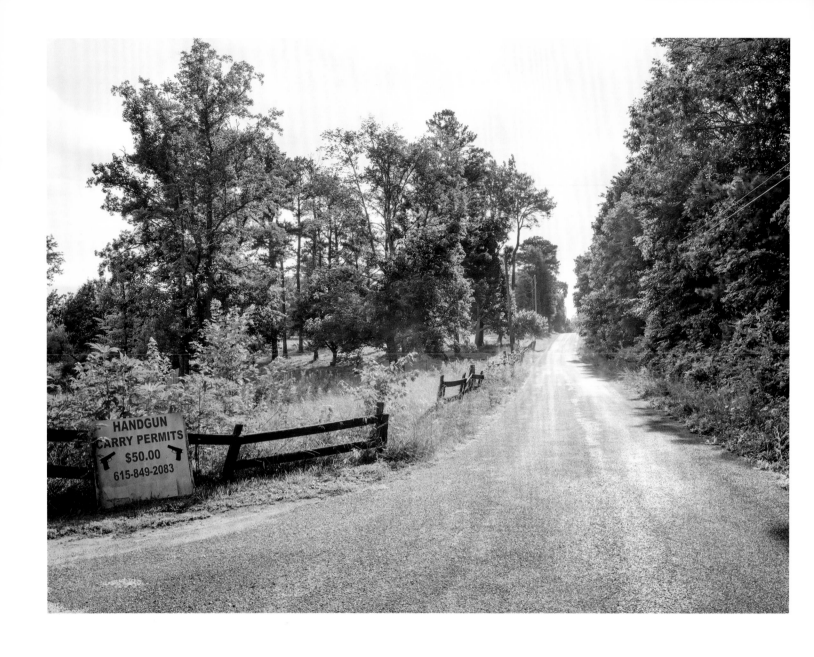

Road to the Highlander Folk School, Monteagle, Tennessee, 2018

Black students learned leadership skills at the Highlander School, founded by Myles Horton in 1932. Its renowned students and teachers included Esau Jenkins, Diane Nash, James Bevel, Dorothy Cotton, Dr. Martin Luther King Jr., and Andrew Young—future organizers of some of the movement's most effective actions, including the Montgomery Bus Boycott. In 1961, the school's charter was revoked and its land seized by the state. It reopened the following day in Knoxville, moving to New Market in 1972, where it remains to this day.

Felix Benjamin Duncan Gaines Mural, Old Depot Museum, Selma, Alabama, 2017

In 1937, Felix Benjamin Duncan Gaines, a Black American painter, completed his monumental mural in the community center in Selma, Alabama. The center had been established with funds from the Works Progress Administration, a New Deal agency that enlisted millions of job-seekers to complete public works projects. In 1992, the murals were moved to Selma's Old Depot Museum.

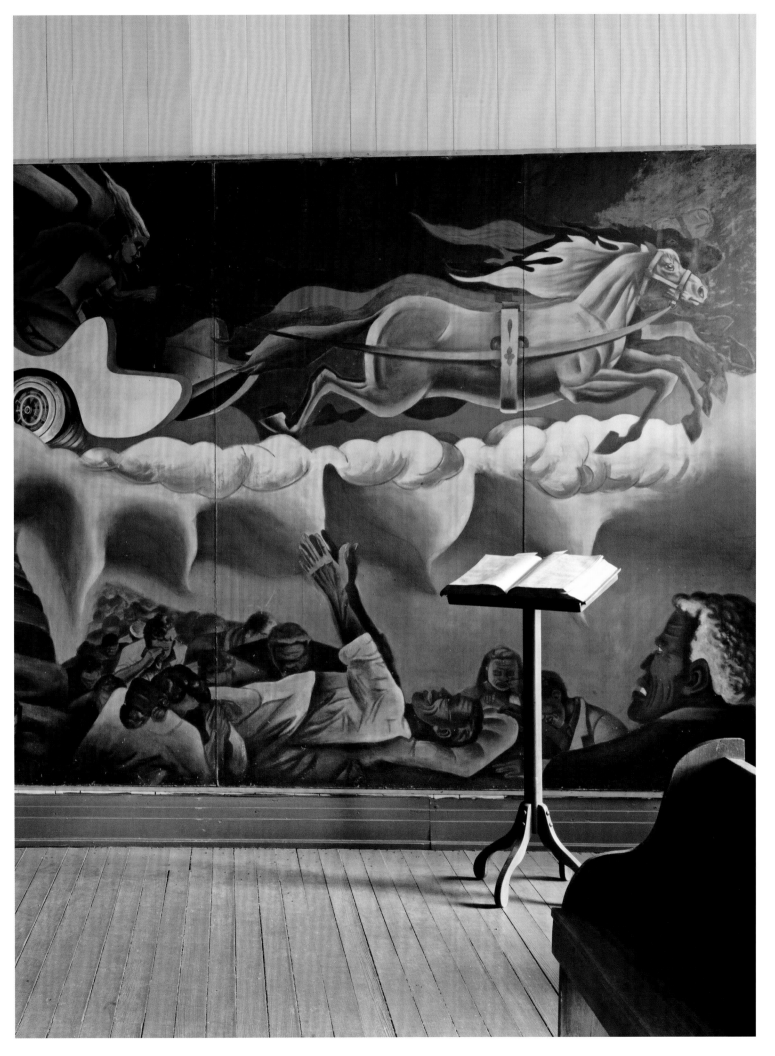

**General Store, Kewanee,
Mississippi, 2018**

President Franklin Delano Roosevelt's
New Deal policies were widely consid-
ered to be socialist. Later, participants
in the civil rights movement would be
labeled socialist and communist by
white Americans resistant to integra-
tion. Ironically, in order to pass much
of his New Deal, Roosevelt needed the
support of the powerful Southern Demo-
crat voting bloc, and therefore held back
any significant federal intervention that
would have weakened Jim Crow. Today,
the term "socialist" has reappeared
as a pejorative in political discourse.

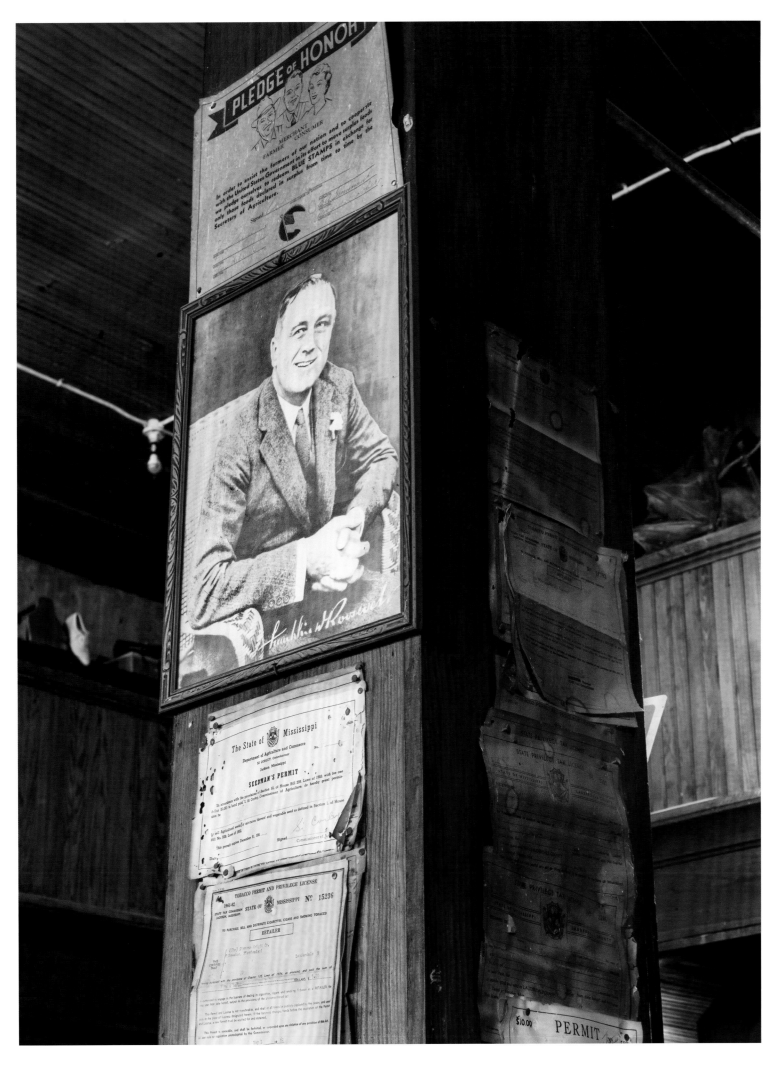

Johns Island, South Carolina, 2018

Esau Jenkins was born in 1910 on Johns Island, South Carolina, where he lived until his death in 1972. In the 1940s, Jenkins and his wife Janie purchased a number of school buses to transport students and workers to Charleston for education and employment. During those bus rides, the couple would teach adult passengers how to pass literacy exams so they could register to vote. Wanting to educate more black South Carolinians in the basics of civic participation, Jenkins founded the Progressive Club in 1948.

Ruins of the Progressive Club, Johns Island, South Carolina, 2018

The Progressive Club was, among other things, a pioneering citizenship school for Black American students. In time, it came to include a community grocery, a gas station, day-care services, and classrooms, as well as providing a barter system in times of privation. The center's education programs resulted in thousands of black citizens registering to vote.

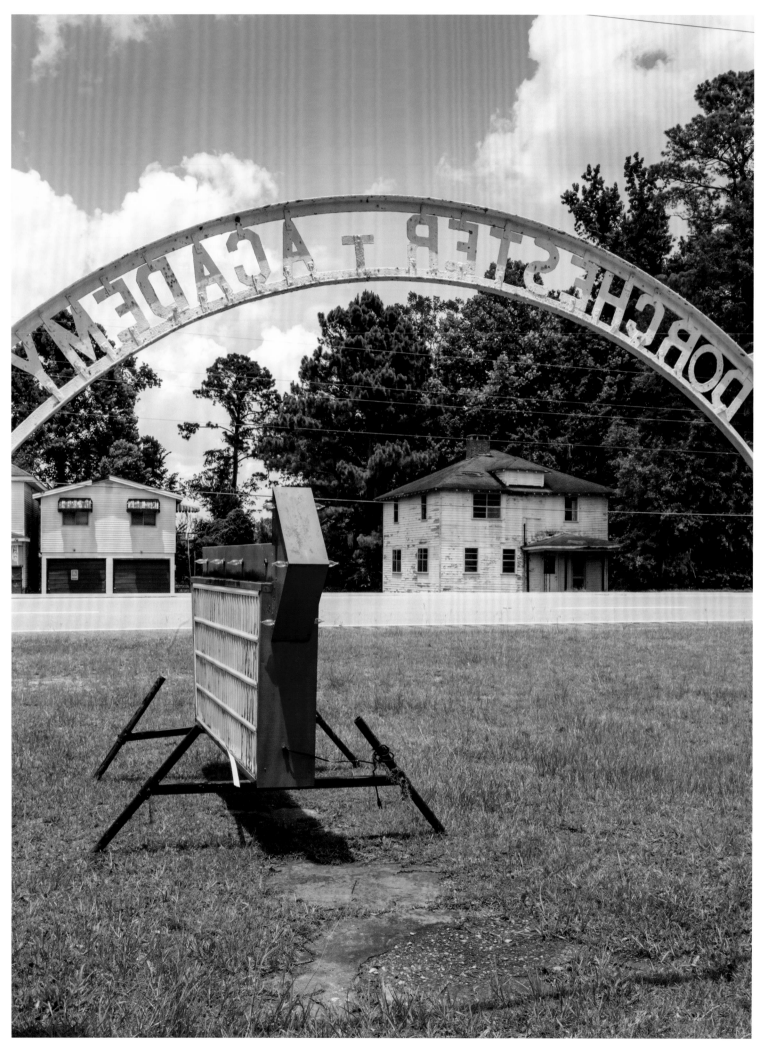

**Dorchester Academy,
Midway, Georgia, 2018**

The Dorchester Academy was founded
around 1870 by Protestant activists to pre-
pare formerly enslaved men and women
for life as free citizens. After the school
closed, its last standing building, a former
dormitory, was converted into a commu-
nity center that served both as headquar-
ters for the SCLC's Citizen Education
Program, started in 1961 by Septima
Poinsette Clark, and as a staging ground
for key civil rights actions, including the
group's 1963 Birmingham campaign.

Little Rock Central High School, Little Rock, Arkansas, 2018

The integration of Little Rock High School following the 1954 Supreme Court decision in *Brown v. Board of Education* was a seismic event. The decision called for the integration of public schools and ignited violent retributions by white supremacists throughout the southern states. The high school's first nine black students, escorted and protected by the National Guard, had to walk through a screaming, taunting crowd of 1,500 angry whites surrounding the school. Many called for the children to be lynched.

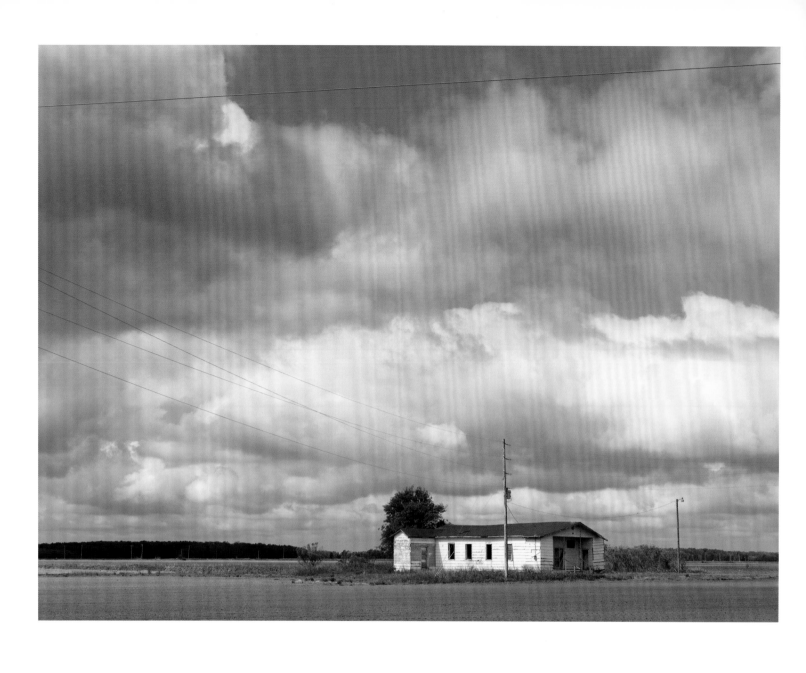

Farm on the Delta, Belzoni, Mississippi, 2018

Black farm and land ownership fell dramatically after 1900 and continued falling through subsequent decades. In 1956, Robert Patterson, one of the founding fathers of the White Citizens' Councils in Mississippi, proposed a plan that would force hundreds of thousands of Black Americans (many of them farmers) from Mississippi. Patterson's plan intended to use economic pressure, layoffs, and intimidation in order to force a mass exodus to the North, and thereby reduce black voting power.

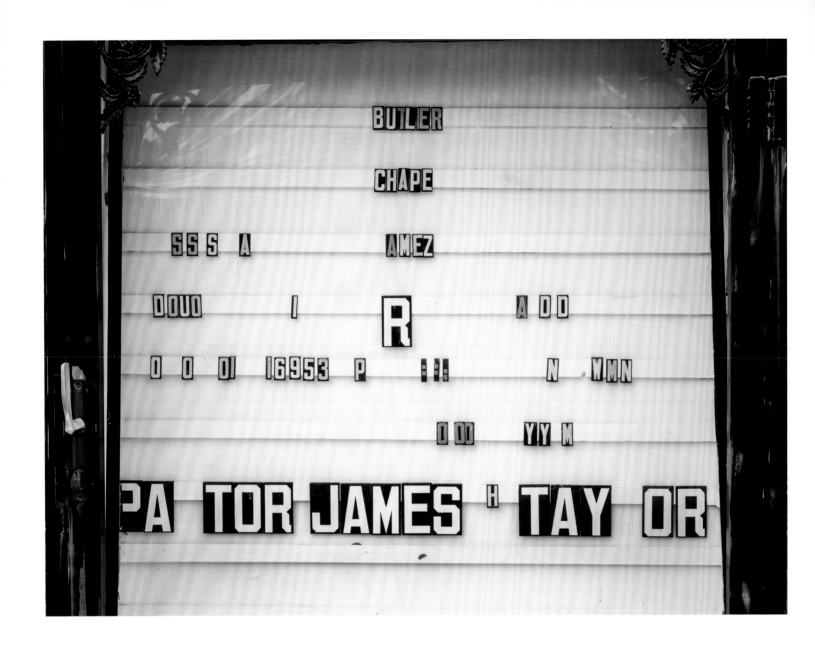

Butler Chapel, Tuskegee, Alabama, 2018

On June 25, 1957, Professor Charles Gomillion of the Tuskegee Civic Association led several thousand people at the Butler Chapel calling for a boycott of white businesses in response to a gerrymandering bill enacted by the all-white Alabama state legislature. In 1960 the Supreme Court unanimously ruled in *Gomillion v. Lightfoot* that the Alabama state legislature had unconstitutionally redrawn the city boundaries of Tuskegee to ensure the election of white candidates. The case, argued by attorney Fred Gray, laid the foundation for the concept of demographically proportional representation, sometimes encapsulated as "one man, one vote."

Dexter Avenue King Memorial Baptist Church, Montgomery, Alabama, 2017

The Dexter Avenue King Memorial Baptist Church in Montgomery, Alabama, was led by Dr. Martin Luther King Jr. from 1954 to 1960. During his tenure as the church's pastor, King helped organize the Montgomery Bus Boycott.

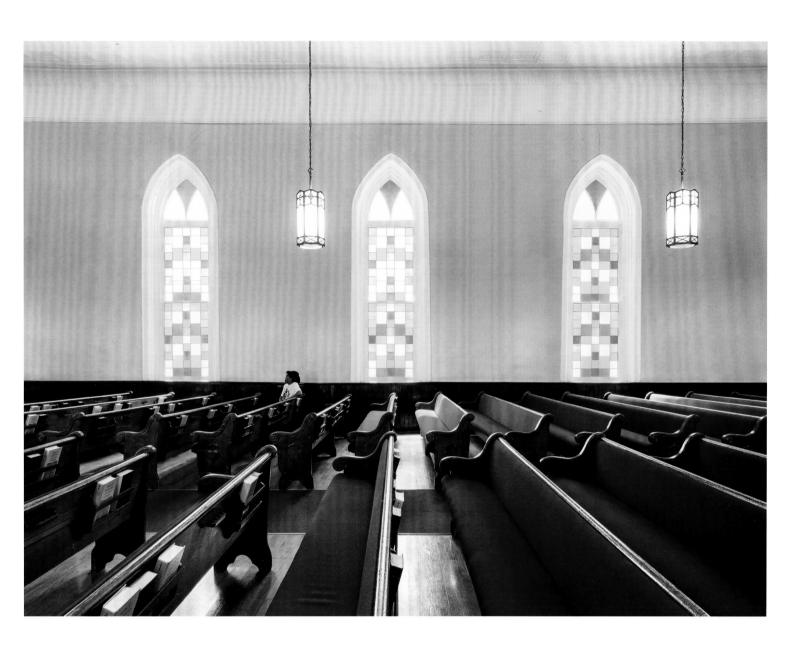

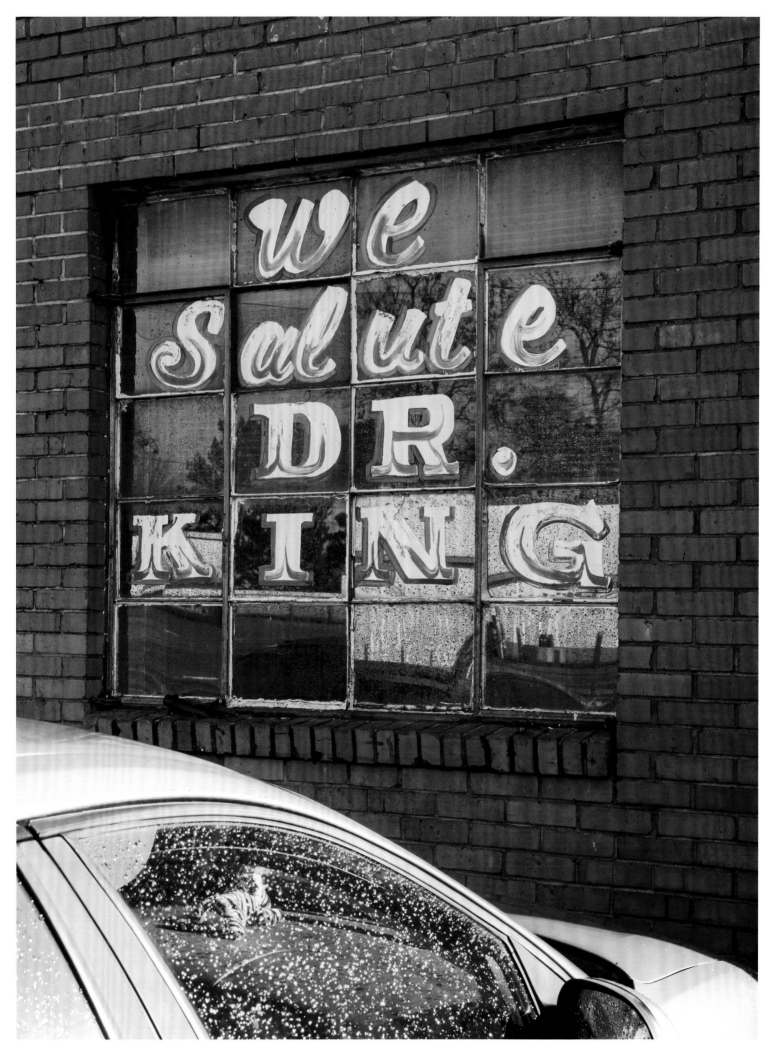

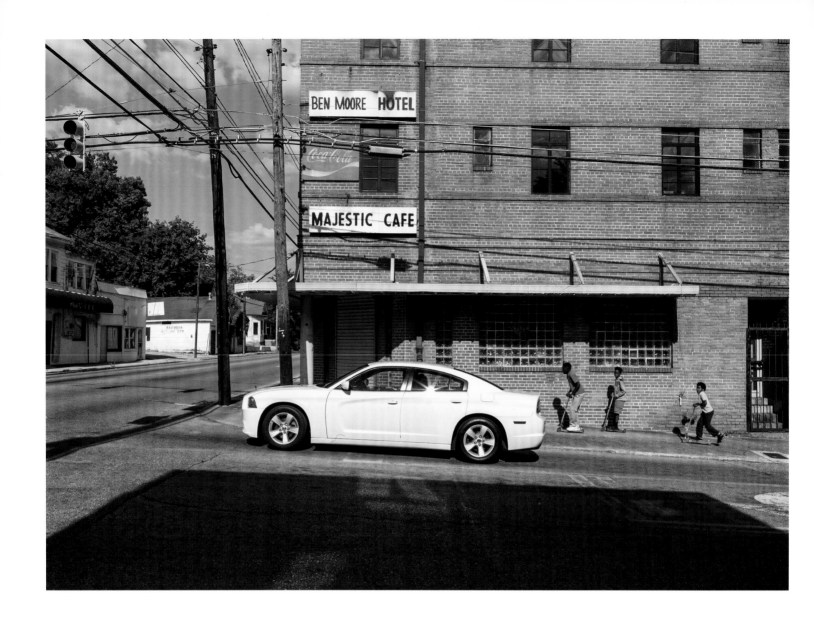

(*previous spread, left*)
Trinity Evangelical Lutheran Church Parsonage, Montgomery, Alabama, 2018

Trinity Evangelical Church was the site of organizing meetings hosted by Rosa Parks, who lived nearby. Because the leader of the church, Reverend Robert Graetz, supported the civil rights movement, he and his family, all white, became targets for the Klan. In 1956 and 1957, the Klan bombed the parsonage where they lived. A hackberry tree was planted by neighbors in one of the craters left by the blasts.

(*previous spread, right*)
Memorial to Dr. King, Jackson, Mississippi, 2018

Memorials to Dr. Martin Luther King Jr. include more than one thousand streets that bear his name around the world. This more modest memorial was seen at McElroy's Body Shop, located on Martin Luther King Drive in Jackson, Mississippi.

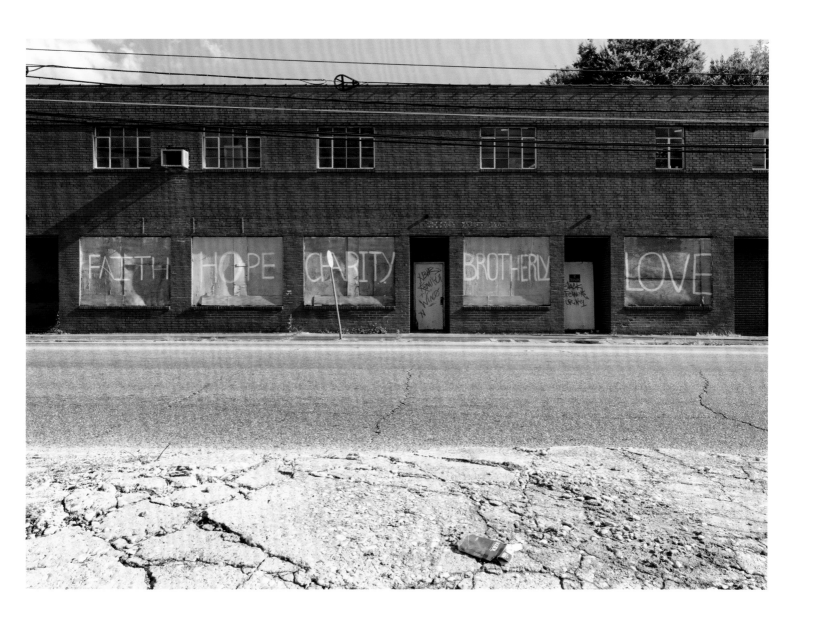

Ben Moore Hotel and Majestic Cafe, Jackson Street, Montgomery, Alabama, 2017

The Ben Moore Hotel in Montgomery was once the home of the Majestic Cafe, a preferred meeting place for the organizers of the Montgomery Bus Boycott.

South Jackson Street, Montgomery, Alabama, 2018

South Jackson Street is a historically black district in Montgomery. It is the location of the Dexter Avenue Baptist Church parsonage, where Dr. Martin Luther King Jr. and his family lived during the bus boycott. The Jackson Street district was also the home of the former slave John Jones, elected to represent Lowndes County, Alabama, as a state senator during Reconstruction.

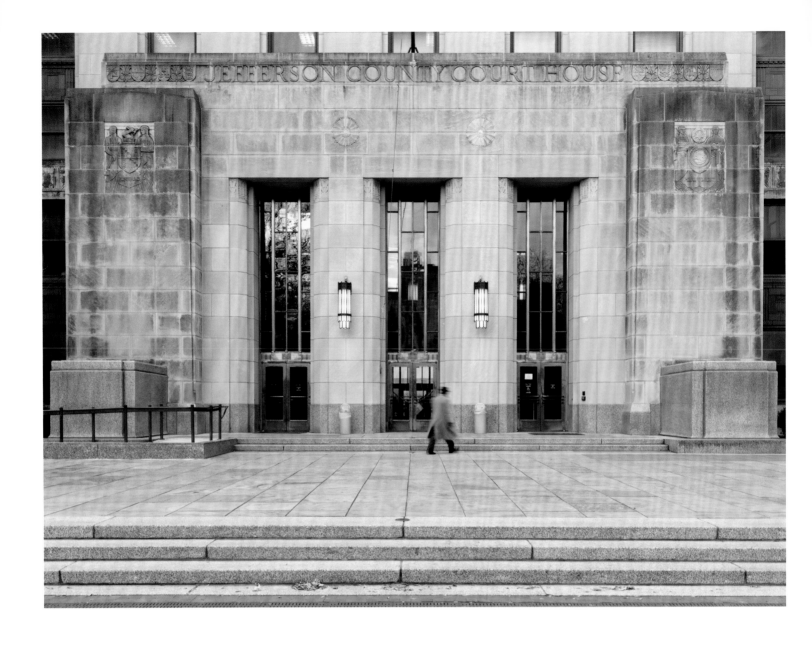

**Jefferson County Courthouse,
Birmingham, Alabama, 2018**

Throughout the 1950s and '60s, black
women who appeared at the Jefferson
County Courthouse to register to vote
were interrogated about whether their
children were born out of wedlock. The
Reverend Fred Shuttlesworth, who
founded the Alabama Christian Move-
ment for Human Rights in 1956, wrote
to the US Department of Justice in 1960
demanding an end to this degrading
practice. In response, the Civil Rights
Division of the attorney general's office
ordered the FBI to investigate.

**Broughton Street, Savannah,
Georgia, 2018**

On March 16, 1960, black students led
by the NAACP Youth Council staged
sit-ins at whites-only lunch counters
along downtown Savannah's Brough-
ton Street. The 1960 sit-in at Wool-
worth's in Greensboro, North Carolina,
which was initiated by students from
North Carolina A&T State University,
had inspired a wave of protests in nearly
every state south of the Mason-Dixon
line that continued until 1964.

**Cravath Hall, Fisk University,
Nashville, Tennessee, 2018**

Fisk University is a historically black university in Nashville, Tennessee. A prestigious incubator of black leadership for more than a century, Fisk boasts notable alumni, including the sociologist W. E. B. DuBois; the attorney, federal judge, New York state senator, and Manhattan borough president Constance Baker Motley; the civil rights leader Diane Nash; and Congressman John Lewis. In the early 1960s, students from Fisk and other universities and high schools in Nashville joined forces to stage nonviolent protests, marches, and sit-ins throughout the city.

**First Baptist Church,
Nashville, Tennessee, 2018**

Nashville was (and remains) the home of the Reverend James Lawson Jr., the godfather of nonviolent civil rights activism in the United States. Lawson is responsible for, among other achievements, mentoring a generation of Nashville-based students who would later lead the civil rights movement, including John Lewis, James Bevel, and Diane Nash. The First Baptist Church was the backdrop for Lawson's teachings on nonviolent resistance, as pioneered by Mahatma Gandhi. The Reverend Kelly Miller Smith offered the church as a refuge for Lawson and his associates as they launched their campaign for integration.

The Lyceum, University of Mississippi, Oxford, Mississippi, 2018

Fifth Street, Birmingham, Alabama, 2018

In 1962 and 1963, the Reverend Fred Shuttlesworth led an economic boycott of white businesses along Birmingham's Fifth Street that refused to desegregate fitting rooms and restrooms. Through direct exchange with business leaders, Shuttlesworth gained significant concessions, but Sheriff Bull Connor continued to actively enforce established segregation laws. Connor's resistance to integration led to the 1963 formation of

SCLC's Project C (for "confrontation"). The core tactic of the resistance was the organization of peaceful demonstrations in and around Birmingham's business district, beginning and ending at the Sixteenth Street Baptist Church. At one such demonstration, Sheriff Connor used firehoses and police dogs against marchers, many of them young children. Still and moving images of that day created another shift in the nation around civil rights.

James Howard Meredith is a civil rights icon, writer, political adviser, and Air Force veteran. In 1962, he became the first Black American student admitted to the University of Mississippi. Among the attorneys representing his efforts to enroll were Constance Baker Motley of the NAACP. During a riot that broke out on the evening of September 30, 1962—the day Meredith arrived on campus—two people, including a French journalist, were killed, and 300 were injured. Federal intervention on campus enabled Meredith's successful enrollment.

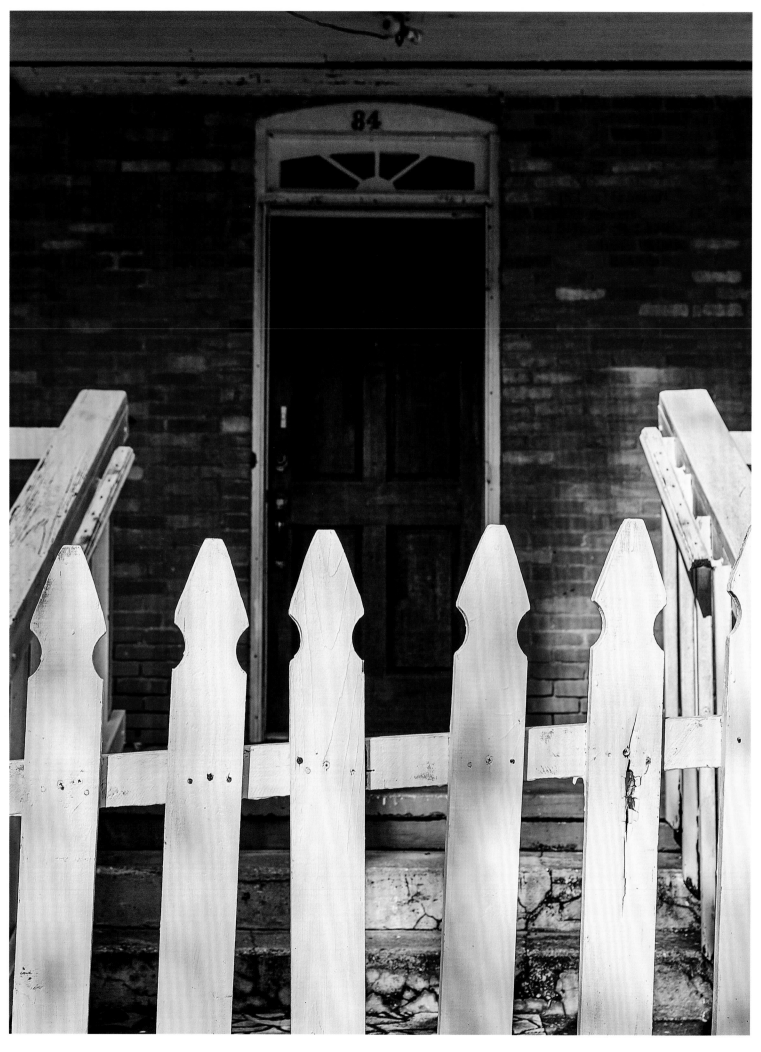

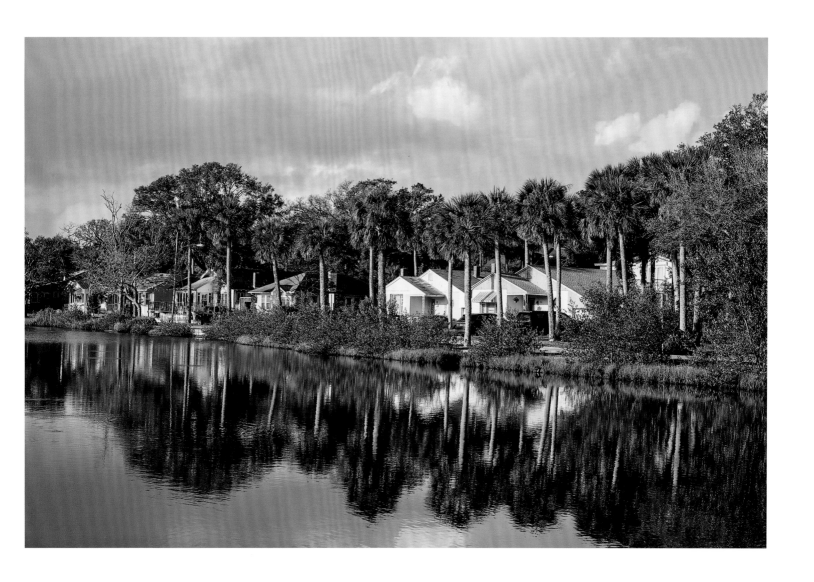

**St. Paul A.M.E. Church Parsonage,
Lincolnville, St. Augustine,
Florida, 2019**

The civil rights struggle met perhaps its most violent resistance in St. Augustine, where SCLC members, including Dr. Martin Luther King Jr., Ralph Abernathy, Andrew Young, Hosea Williams, C. T. Vivian, Fred Shuttlesworth, Willie Bolden, J. T. Johnson, and Dorothy Cotton, joined local organizers led by Dr. Robert Hayling in marches and widely publicized beach wade-ins. Violent retaliations by white supremacists were swift and brutal. National headlines followed when supporters from New England traveled south to participate in these protests, and several of them (including Mary Parkman Peabody, the seventy-two-year-old mother of the governor of Massachusetts) were arrested and jailed for refusing to leave a sit-in at the Ponce de León Restaurant. On June 18, 1964, activists jumped into the whites-only swimming pool at the Monson Motor Lodge in response

to the arrest of Dr. King the preceding week, when he had attempted to enter the motel's restaurant. The motel owner poured muriatic acid into the water to eject the protestors. The senate passed the Civil Rights Act of 1964 the following day.

The town of Lincolnville was founded by freedmen and women at the end of the Civil War. The Reverend Shepherd Hunter, pastor at the nearby St. Paul A.M.E. Church, lived in this Lincolnville house throughout the 1940s. St. Paul A.M.E. played a key role in the civil rights movement, hosting speeches by the baseball Hall-of-Famer Jackie Robinson and Dr. Martin Luther King Jr. King's visit attracted crowds so immense that organizers held a simultaneous rally next door at the First Baptist Church so more people could hear him speak.

**Lincolnville, St. Augustine,
Florida, 2019**

In 1963, tensions escalated in St. Augustine, Florida, around the issue of school desegregation. Among other acts of terror, an arsonist burned down the home of a black family whose child had integrated a white school. In October of that year, a carload of Klansmen raced through the black neighborhood of Lincolnville, shooting indiscriminately into homes. Blacks returned fire, killing one of the Klansmen. The NAACP activist Reverend Goldie Eubanks and three others were indicted for the killing.

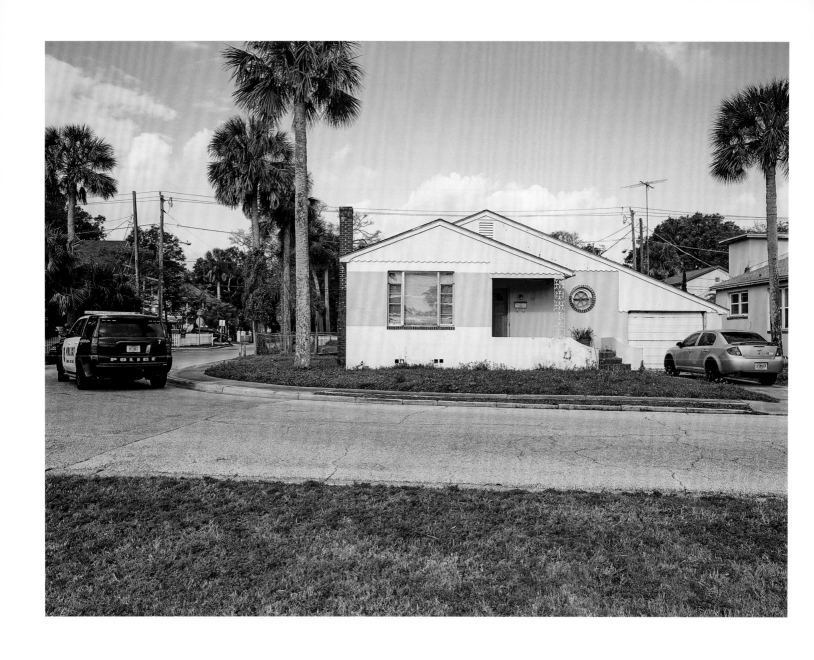

**Lincolnville, St. Augustine,
Florida, 2019**

Andrew Young was sent to St. Augustine
by Dr. King in 1964 to suspend protests
there as debate on the Civil Rights Act
was underway in Washington, DC.
Arriving in St. Augustine, Dr. King's
special projects director, Hosea Wil-
liams, convinced Young to lead a night
march to Plaza de la Constitución, where
marchers were met by members of the
Klan. Young, attempting to negotiate
with Klansmen blocking the entrances
to the plaza, was beaten, but continued
leading the procession successfully to its
destination.

**Confederate Monument, Plaza de la
Constitución, St. Augustine,
Florida, 2019**

In 2018, the St. Augustine City Council
voted to add material providing histori-
cal context to the monument shown here
rather than remove it. In 2020, in the
wake of the murder of George Floyd, an
unarmed Black American man, by Min-
neapolis police, St. Augustine city com-
missioners voted 3-2 in favor of moving
the monument out of the plaza.

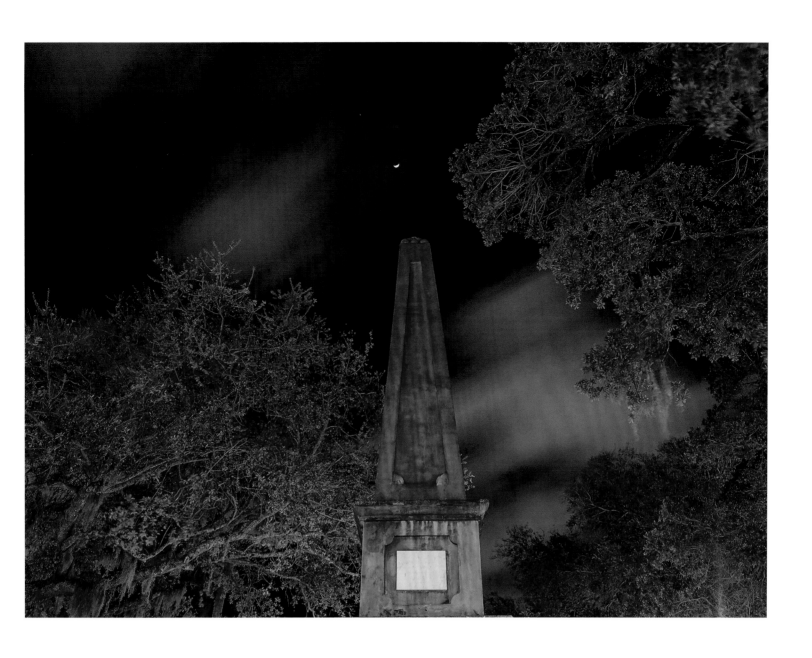

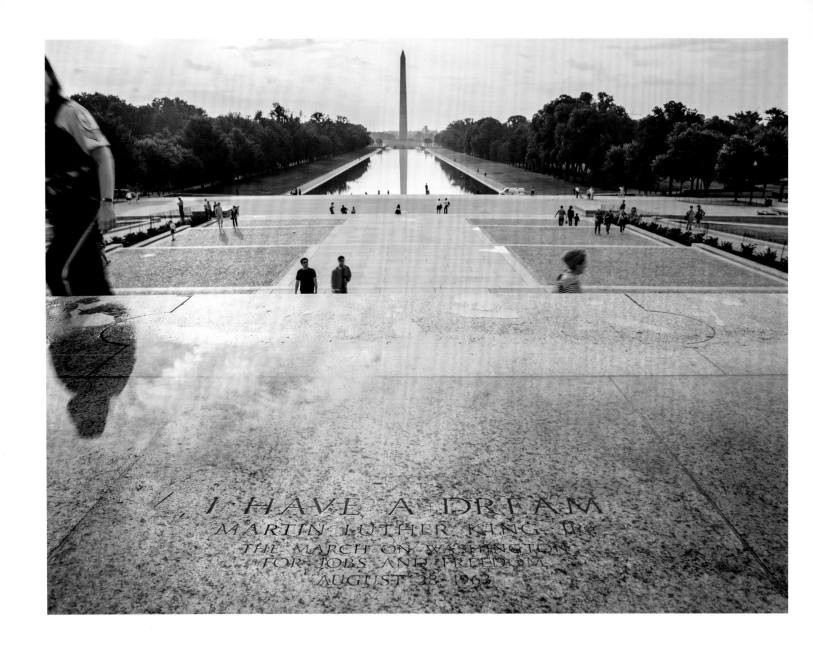

**The Lincoln Memorial,
Washington, DC, 2018**

The March on Washington of August
28, 1963, was organized by a coalition
of civil rights groups. It attracted some
250,000 people to the Washington Mall,
where Dr. King gave his iconic "I Have a
Dream" address. The event, one of the
largest political rallies for human rights
in US history, is credited with helping
pass the Civil Rights Act of 1964.

**Sixteenth Street Baptist Church,
Birmingham, Alabama, 2018**

On September 15, 1963, KKK members
bombed Birmingham's Sixteenth Street
Baptist Church, killing four young girls
attending services there and wounding
many others. The park adjacent is now
dedicated to the victims of the bombing
and the area's civil rights history.

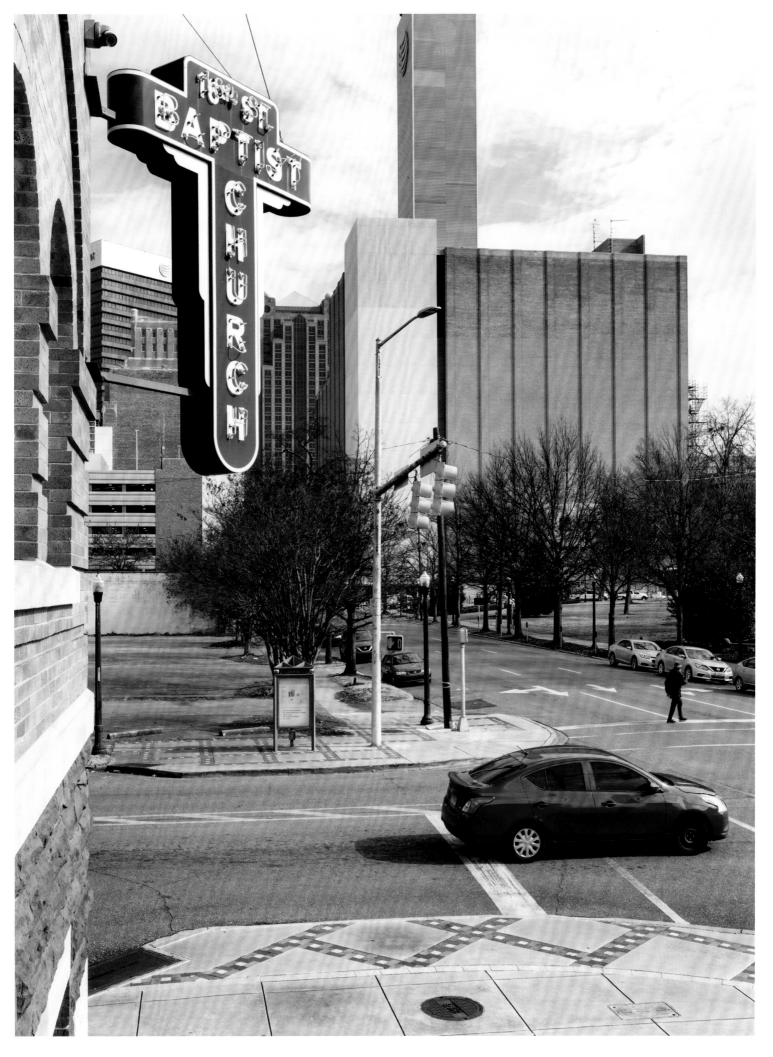

The E. F. Young Jr. Hotel, Meridian, Mississippi, 2018

Through the 1960s, Meridian's E. F. Young Jr. Hotel was the only such business serving black patrons. One of the state's few hotels owned by an African American, it welcomed a long list of distinguished guests, including Constance Baker Motley, Leontyne Price, Ella Fitzgerald, and Dr. Martin Luther King Jr. The E. F. Young Jr. Hotel remained in operation until 1978, when the building was rented to office tenants. In recent years it has lain entirely vacant.

**Site of the Attack on Jimmy Travis,
Bob Moses, and Randolph Blackwell,
Route 82 outside Greenwood,
Mississippi, 2018**

On February 28, 1963, Jimmy Travis, a
SNCC field secretary, was driving SNCC
project director Bob Moses and SNCC
Voter Education Project worker Ran-
dolph Blackwell to Greenville, Missis-
sippi when a flurry of bullets hit the car.
Badly wounded, Travis barely survived.
The incident ignited the already fraught
situation in the Mississippi Delta. Press
attention and a spike in voter registrants
in Greenwood spurred additional repri-
sals by white supremacists. For its part,
the local coalition of civil rights organi-
zations responded with a renewed deter-
mination to continue registration efforts.

**Main Street, Plaquemine,
Louisiana, 2019**

In 1963, members of CORE, as well as
one of the group's leaders, James Farmer,
were working on a voter registration
campaign in the eight southeastern par-
ishes of Louisiana's sixth congressional
district. Since the effort began the year
before, the campaign had registered
450 Black Americans to vote and filed
over 200 discrimination complaints with
the US Department of Justice. Peaceful
marches, one in the summer of 1963
and one in the fall, were met with tear
gas and mounted police. Farmer had to
evade police and white supremacists
threatening to lynch him by hiding
in a local funeral home.

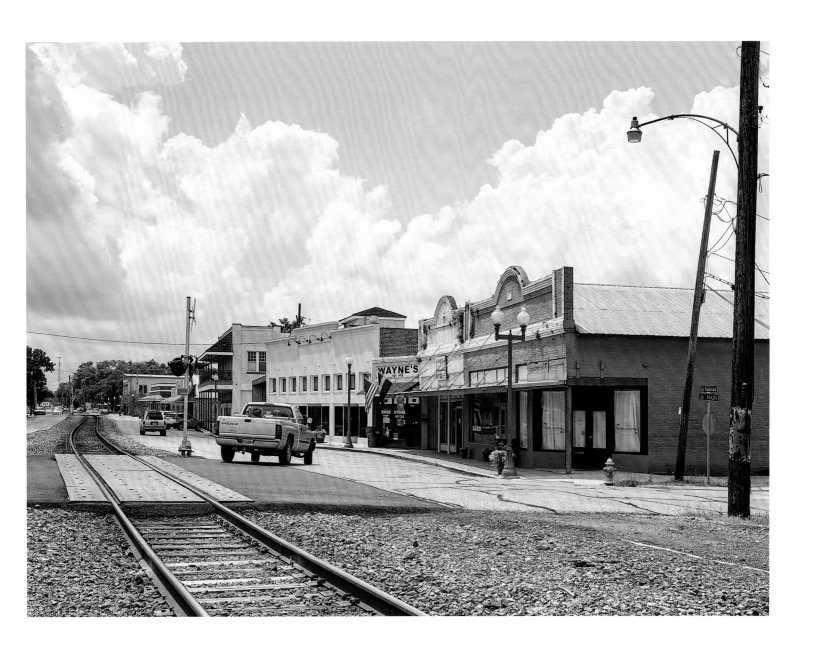

(*following spread*)
**Delta Landscape, Ruleville,
Mississippi, 2018**

Fannie Lou Hamer was born in Montgomery County, Mississippi, on October 6, 1917. She lived and worked on a plantation in Ruleville in Sunflower County until becoming involved in the civil rights movement in 1962. In June 1963, Hamer and several others were beaten by police and jailed for three days in Winona, Mississippi, as they returned from a voter registration workshop in Charleston, South Carolina. A fiery orator and organizer, Hamer was invited to testify before the credentials committee at the 1964 Democratic National Convention in Atlantic City. Her passionate speech, which was scheduled to be broadcast live on TV, was preempted when the Johnson White House hastily announced a press conference to pull attention from Hamer's anxiously anticipated presentation. The country was able to hear her emotional words later that night, when national networks aired her testimony. Hamer was speaking to convince the committee to seat the democratically elected members of the Mississippi Freedom Democratic Party (MFDP). As a compromise, the Democrats offered two seats to the MFDP. The offer was rejected. "We didn't come all this way for no two seats since all of us is tired," said Hamer.

Foster Auditorium, University of Alabama, Tuscaloosa, Alabama, 2018

George Wallace defiantly pledged "Segregation now, segregation tomorrow, and segregation forever" at his inauguration as Alabama's governor in January 1963. Following up on that pledge six months later, Wallace stood in the door of Foster Auditorium at the University of Alabama to block the enrollment of Vivian Malone and James A. Hood, two black students, then accompanied by federal officials. President Kennedy had already ordered up National Guard troops, and Wallace, knowing his gesture was futile, stepped aside rather than incite violence. The next day, Medgar Evers was murdered in Jackson, Mississippi.

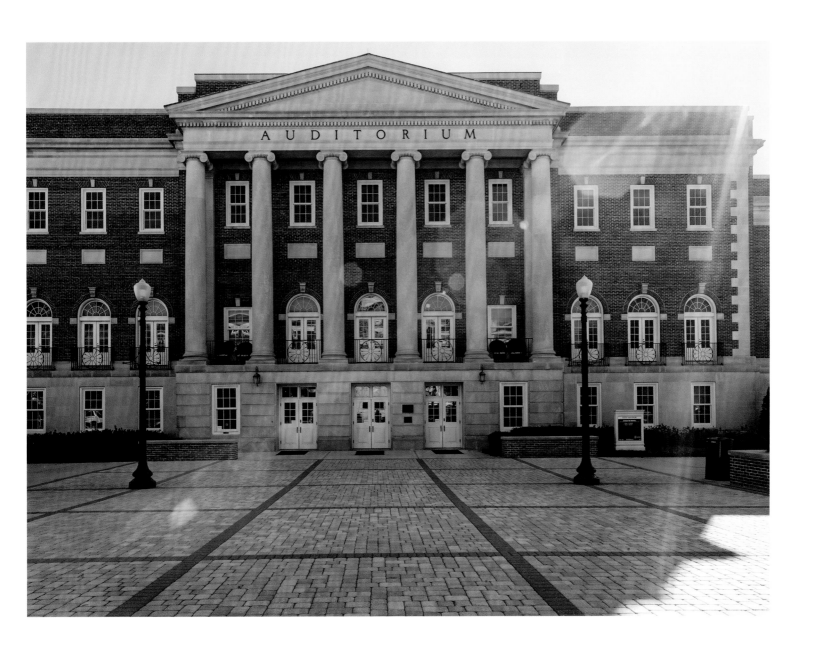

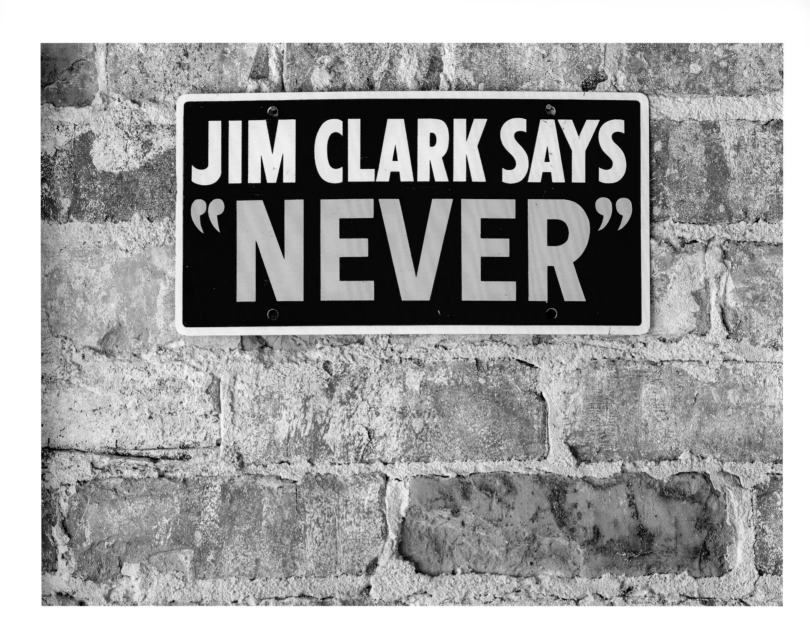

**The Old Depot Museum,
Selma, Alabama, 2017**

James Gardner Clark Jr., better known as
Jim Clark, was sheriff of Dallas County,
Alabama, from 1955 to 1966—the most
tumultuous years of the civil rights move-
ment. Sheriff Clark was, among other
things, responsible for the violent mea-
sures taken against protesters during the
Selma-to-Montgomery marches of 1965,
including the clash on the Edmund Pet-
tus Bridge. Claiming as his motto "Never"
(in reference to integration and voting
rights), Clark was one of the twentieth
century's foremost and most violent seg-
regationist icons. In his obituary, the *New
York Times* said he was "enshrined in the
museum of public brutality."

(following spread)
**Edmund Pettus Bridge, Selma,
Alabama, 2017**

This bridge is named for Edmund
Pettus, a Confederate general, grand
dragon of the KKK, and US senator. It
was the site of three attempts to march
from Selma to Montgomery. The first
ended when marchers halted and knelt
to pray at the sight of mobs, police offi-
cers, and state troopers prepared to
stop them. The second took place on
"Bloody Sunday," March 7, 1965, when
mounted police attacked, beat, and
gassed demonstrators. The marchers
finally crossed the bridge with federal
court support on March 21, arriving at
the State Capitol on March 25.

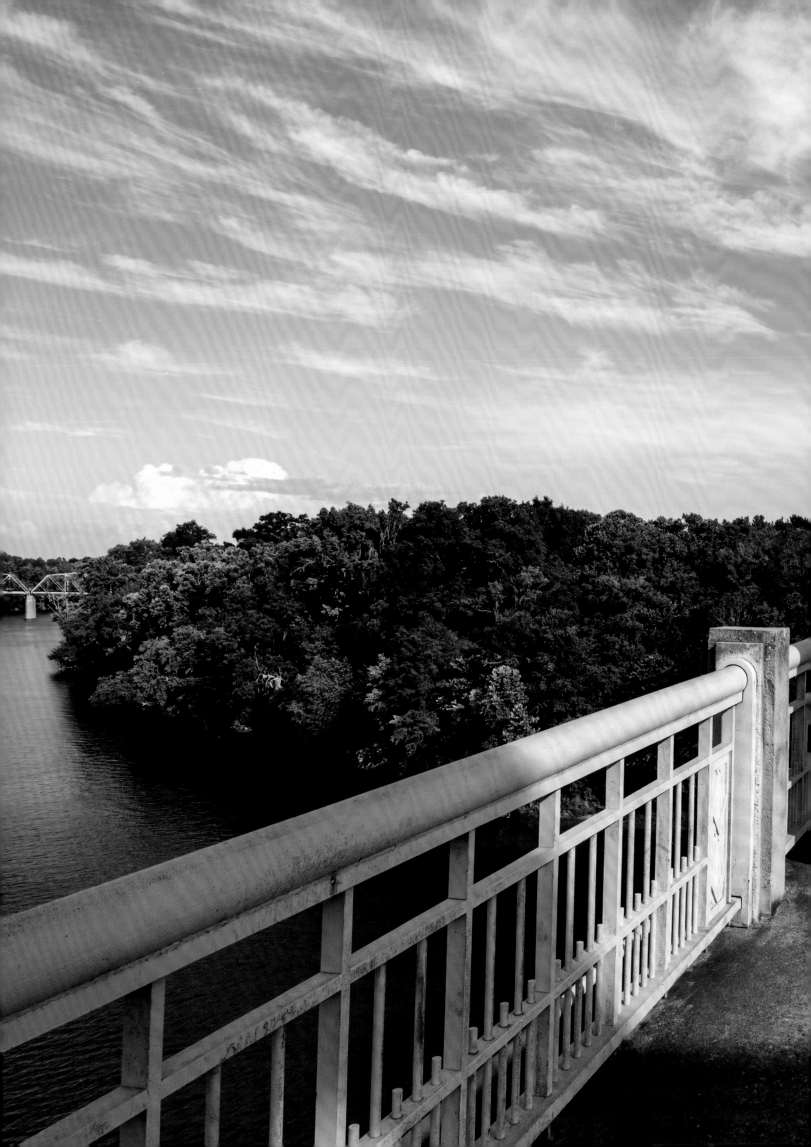

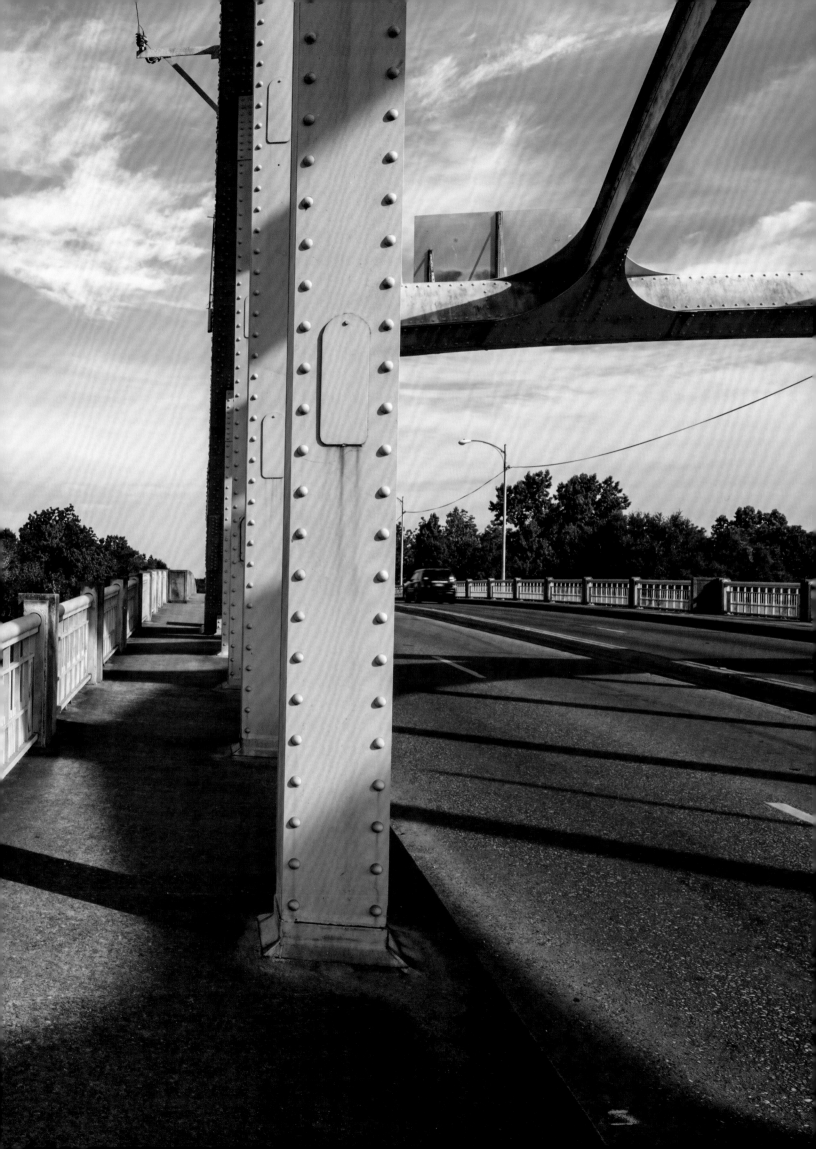

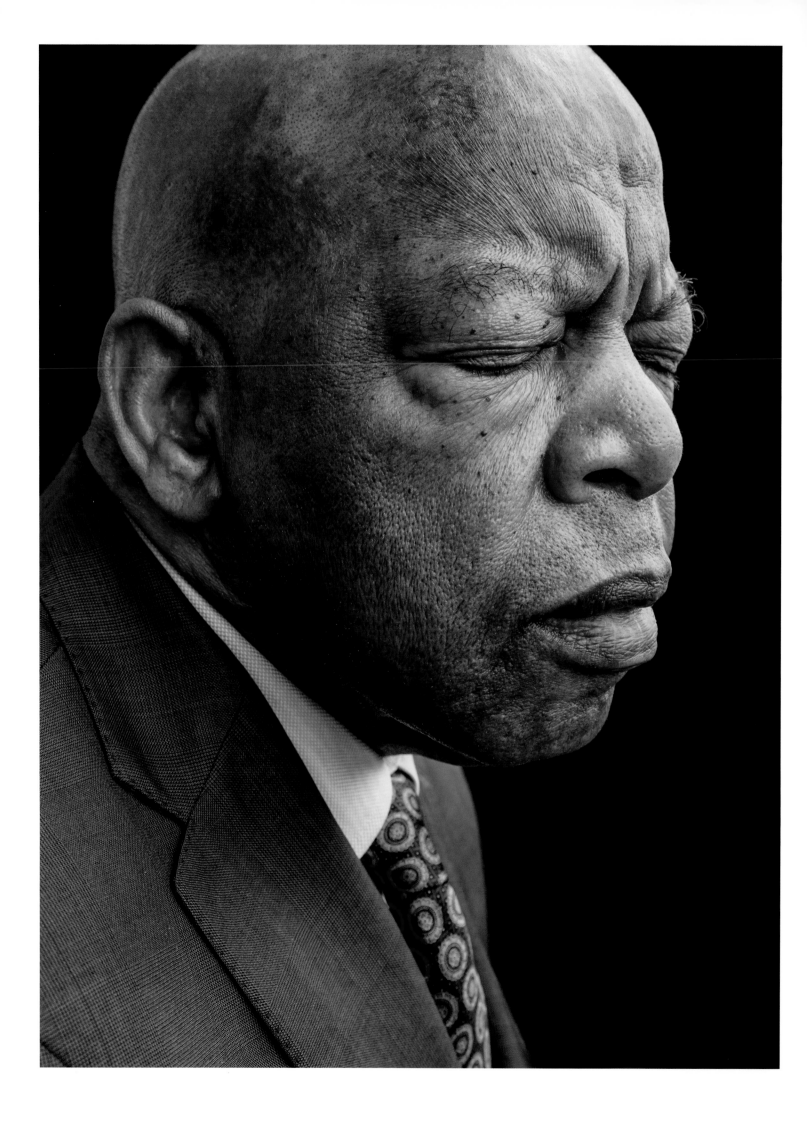

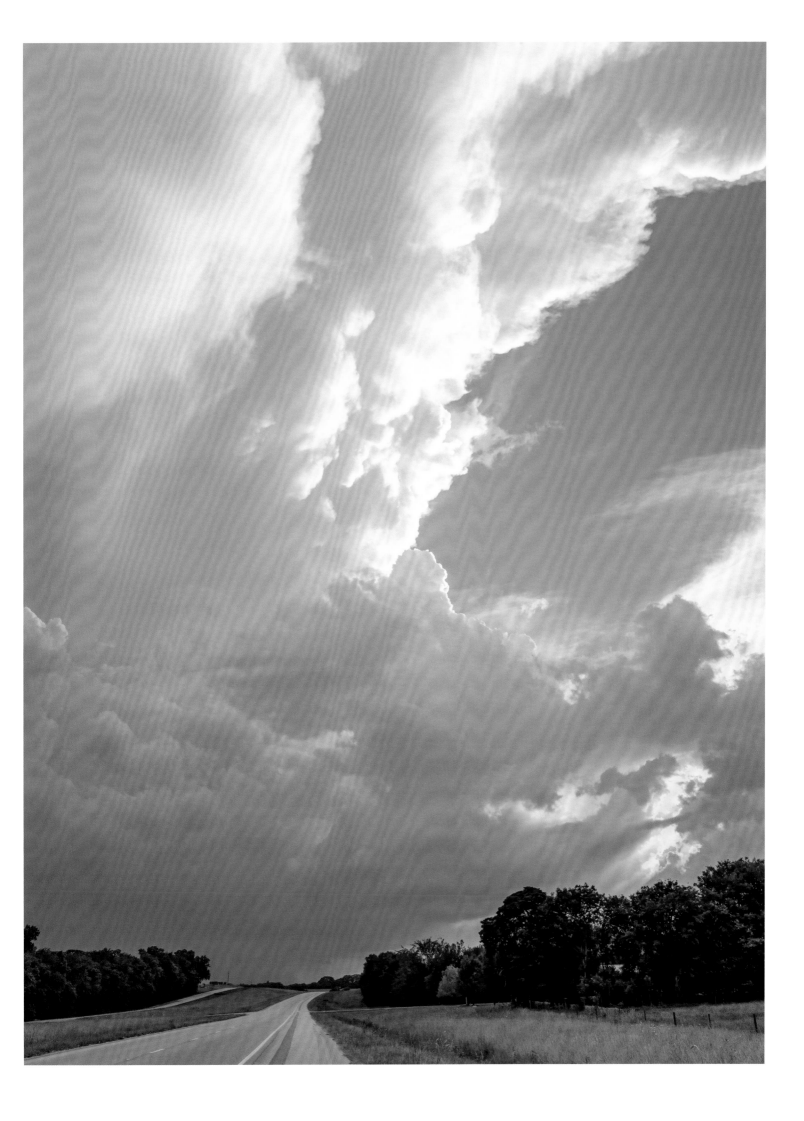

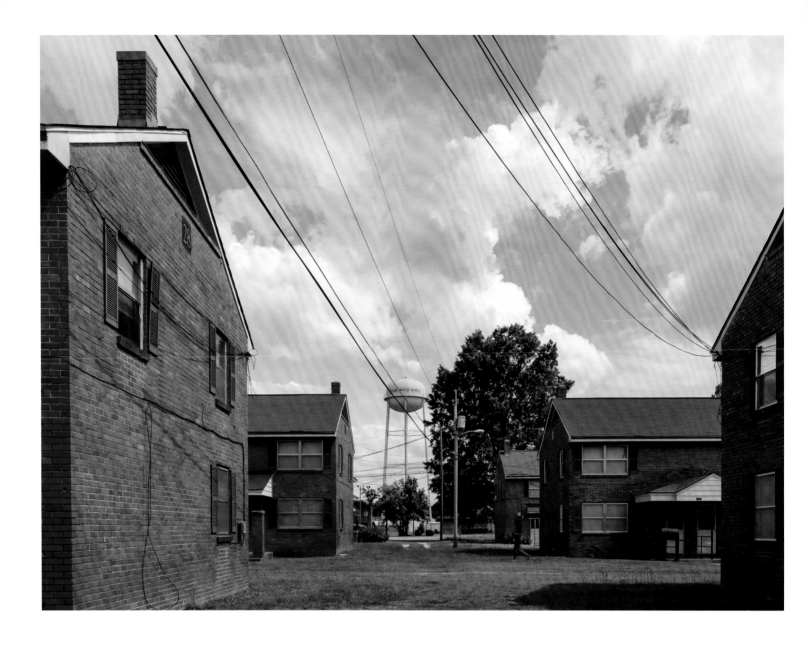

**Congressman John L. Lewis,
Washington, DC, June 6, 2018**

John Lewis, the congressman from
Georgia, led SNCC while still a student
at Fisk University. During the civil rights
era, he suffered frequent beatings at the
hands of police and counterprotesters
and was arrested more than forty times.
On social media and in speeches,
Congressman Lewis's calls to action
have encouraged people to get into
"good trouble, necessary trouble." He has
said, "The vote is the most important
nonviolent tool we have."

**US Route 80, Lowndes County,
Alabama, 2017**

After being repelled by uniformed offi-
cers at the Edmund Pettus Bridge on
March 7, 1965, the Selma-to-Montgom-
ery marchers attempted another crossing
two days later. Though troopers agreed to
let them pass, Dr. Martin Luther King Jr.
held back, determined to wait for federal
protection. Finally, on March 21, a third
attempt was made with the protection
of 1,900 Alabama National Guardsmen
under the federal command of Presi-
dent Lyndon Johnson. Marching down
US Route 80, known as "Jefferson Davis
Highway" (after the president of the
Confederacy), the demonstrators, whose
numbers had risen to an estimated
25,000, entered Montgomery on March
24, approaching the State Capitol the
following day. There, Dr. King gave the
speech known as "How Long, Not Long."

George Washington Carver Homes, Selma, Alabama, 2018

The George Washington Carver Homes, named for the African American agricultural scientist and inventor born into slavery in the early 1860s, stand adjacent to the Brown A.M.E. Chapel in Selma. A number of civil rights organizers, activists, and marchers, many of whom were involved in the Selma-to-Montgomery Marches, came from this neighborhood.

City of St. Jude's Complex, Montgomery County, Alabama, 2018

During the Selma-to-Montgomery March, activists camped on private land owned by those sympathetic to the cause. On the march's final night, thousands slept at a campsite at the City of St. Jude complex, a Catholic institution comprising a school, a hospital, and a church just outside Montgomery. The following morning, they proceeded to the State Capitol building, 25,000 strong. This photograph was made on June 6, 2018, the fiftieth anniversary of the assassination of Robert F. Kennedy Jr. at the Ambassador Hotel in Los Angeles. Lewis, who had been campaigning for Kennedy, was in his hotel room that night, watching Kennedy's speech to supporters on TV, when Kennedy was fatally shot.

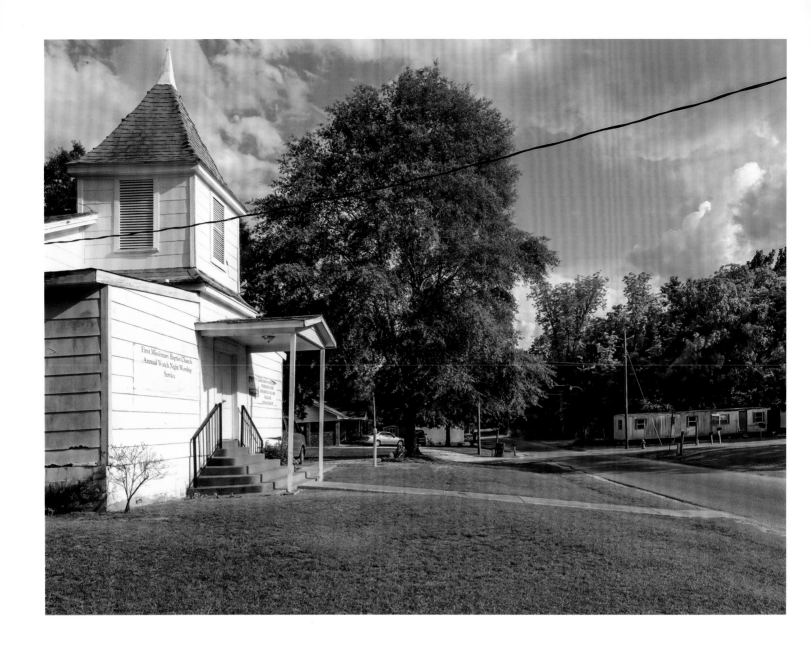

Lowndes County, Alabama, 2017

Lowndes County, thirty miles east of Selma, saw so much violence against Black Americans during the voting rights movement that it bore the nickname "Bloody Lowndes." Though Lowndes County was 80 percent black in 1965, not a single Black American citizen was registered to vote. That year, Stokely Carmichael, a SNCC leader and future "honorary prime minister" of the Black Panther Party, arrived in the county to organize voter registrations, leading to the formation of the Lowndes County Freedom Organization. The organization chose a black panther as its symbol and "Black Power" as its motto.

First Baptist Church, Hayneville, Lowndes County, Alabama, 2017

The First Baptist Church was Lowndes County's first polling place for blacks. At the start of 1965, Lowndes County was 80 percent black, with 5,122 eligible black voters. Not a single one was registered. By 1966, through the registration efforts of activists such as Stokely Carmichael, more than 900 voted in local elections.

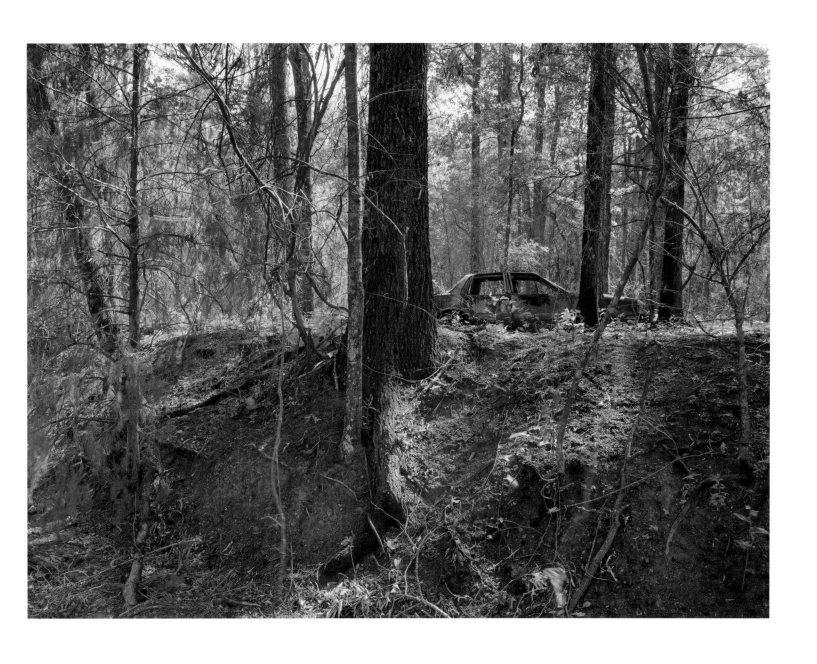

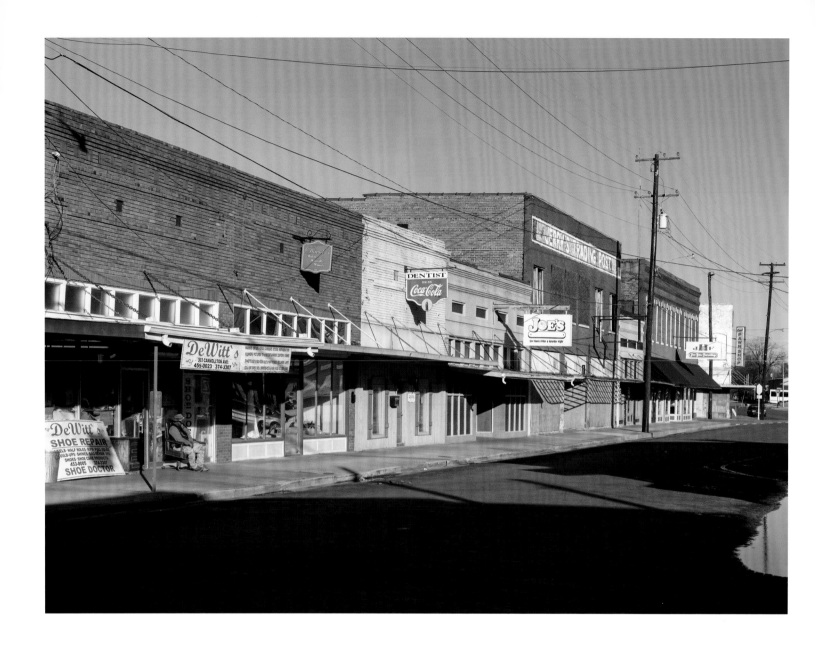

Carrollton Street, Greenwood, Mississippi, 2018

On June 7, 1966, James Meredith, who in 1962 had become the first black student admitted to the University of Mississippi, organized the March Against Fear, a walk from Memphis, Tennessee, to Jackson, Mississippi, to embolden blacks to register to vote and defy segregationist policies. He was shot on the second day by an unidentified assailant, but the march continued, led by the nation's three leading civil rights organizations: SCLC, CORE, and SNCC. Days later they proceeded down Carrollton Street toward Jackson, the capital of Mississippi. Meredith had by then recovered, rejoining the march before it reached its final destination.

Veterans' Gravesite, Broad Street Park, Greenwood, Mississippi, 2018

In 1966, the twenty-four-year-old activist Stokely Carmichael walked out of jail and onto Broad Street to find some six hundred supporters awaiting his release at a park adjacent to this cemetery. To the assembly, he declared: "We want black power!" The slogan resonated throughout the nation.

Gantt Cottage, Penn Center, St. Helena Island, South Carolina, 2019

Penn Center on South Carolina's St. Helena Island is the site of the former Penn School, one of the country's first schools for formerly enslaved citizens. During the 1960s, it hosted retreats and organizing sessions for the SCLC. The Center's Gantt Cottage was home to Dr. Martin Luther King Jr during the sessions and retreats he attended. Still in operation, Penn Center focuses on Black American education, historic preservation, and social justice. It is an important site for the tens of thousands of descendants of enslaved West and Central Africans living in South Carolina's Sea Islands, known as the Gullah-Geechee people.

**Morris Dees,
Montgomery, Alabama, 2018**

In 1981, a nineteen-year-old Black American man named Michael Donald was lynched by two members of the local KKK aiming to intimidate the local black community. Two men were convicted of the murder, with one of them sentenced to death and later executed; the attorney Morris Dees, cofounder of the Southern Poverty Law Center in Montgomery, Alabama, then won a settlement of seven million dollars for Donald's family. The victory bankrupted the United Klans of America in 1987.

**Jimmy Carter's Campaign
Headquarters, Plains, Georgia, 2019**

In 1976, Jimmy Carter, the Georgia governor, gave Democrats a short-lived comeback in the South, winning the presidency with every state in the former Confederacy except for Virginia, which he lost by a narrow margin. In his 1980 loss to Ronald Reagan, however, the only southern states he won were his home state and West Virginia. 1976 was, in fact, the last year a Democratic presidential candidate won a majority of southern electoral votes. Ronald Reagan took all the region's electoral votes in the 1984 election and every southern state except West Virginia in 1988.

(following spread)
Portraits of the Reverend Dr. Martin Luther King Jr. and President and Mrs. John F. Kennedy, Dexter Avenue Parsonage Office, Montgomery, Alabama, 2017

These portraits hang in the parsonage office of the Dexter Avenue King Memorial Baptist Church, where Dr. King lived and ministered from 1954 to 1960. During King's tenure as pastor, the church was bombed several times by the KKK. Along with depictions of Jesus Christ, portraits of the Kennedys and Dr. King were common fixtures in Black American homes throughout the civil rights movement.

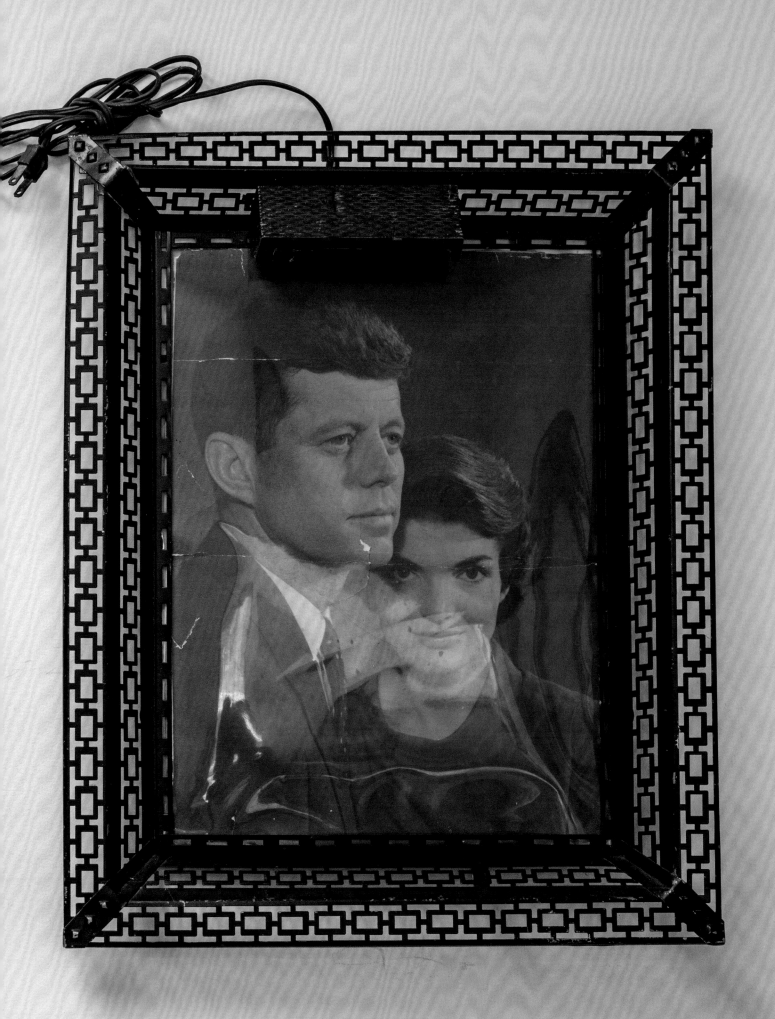

PART III
REVIVAL

**Portraits of the Obamas and Prominent
Black Leaders, Ebenezer Baptist
Church, Atlanta, Georgia, 2019**

Let's be clear. Voter suppression is real.
From making it harder to register and
stay on the rolls to moving and closing
polling places to rejecting lawful ballots,
we can no longer ignore these threats to
democracy.

(Stacey Abrams)

Mitchell County, Georgia, 2019

The battle flag of the Army of Northern Virginia, now commonly referred to as the Confederate flag, holds a charged presence throughout the United States. To some, it is a symbol of pride and heritage. To others, it embodies the South's legacy of racism, voter suppression, injustice, and oppression. The latter sentiment has been reinforced by the flag's adoption by perpetrators of racist violence, including Dylann Roof, convicted of shooting nine black worshipers at Emanuel African Methodist Episcopal Church in Charleston, South Carolina, in 2015, as well as the white supremacist groups that gathered in Charlottesville, Virginia, for the Unite the Right Rally in 2017.

The Reverend William J. Barber II, Goldsboro, North Carolina, 2019

Bishop William J. Barber II is a Protestant minister and describes himself as a moral activist. A member of the national board of the NAACP, he serves as the chair of its Legislative Political Action Committee and is a past president of the association's North Carolina chapter. Barber is the pastor of Goldsboro's Greenleaf Christian Church (Disciples of Christ). In May 2017 Barber announced that he and the Reverend Liz Theoharis would lead the Poor People's Campaign: A National Call for a Moral Revival, in honor of the original campaign initiated by Dr. Martin Luther King Jr. in 1968. In a 2019 Ted Talk with the Reverend Theoharis, Bishop Barber said, "The same states that attack voting rights are also high poverty states, and they elect politicians through racist voter suppression, then pass policies that hurt mostly white people and children and women."

(following spread, right)
The Reverend Dr. Liz Theoharis, Union Theological Seminary, New York City, 2019

Liz Theoharis is a Presbyterian pastor and biblical scholar. She is the director of the Kairos Center for Religions, Rights, and Social Justice at Union Theological Seminary in New York City and, along with the Reverend Dr. William J. Barber II, a cochair of the Poor People's Campaign: A National Call for a Moral Revival. In 2018, calling for a massive wave of nonviolent civil disobedience, Theoharis said, "We must love this democracy enough to go to jail in nonviolent civil disobedience for it, to organize in the streets for it, to sue in the courts for it, and to register everybody, everybody, everybody we know to vote at the ballot box for it."

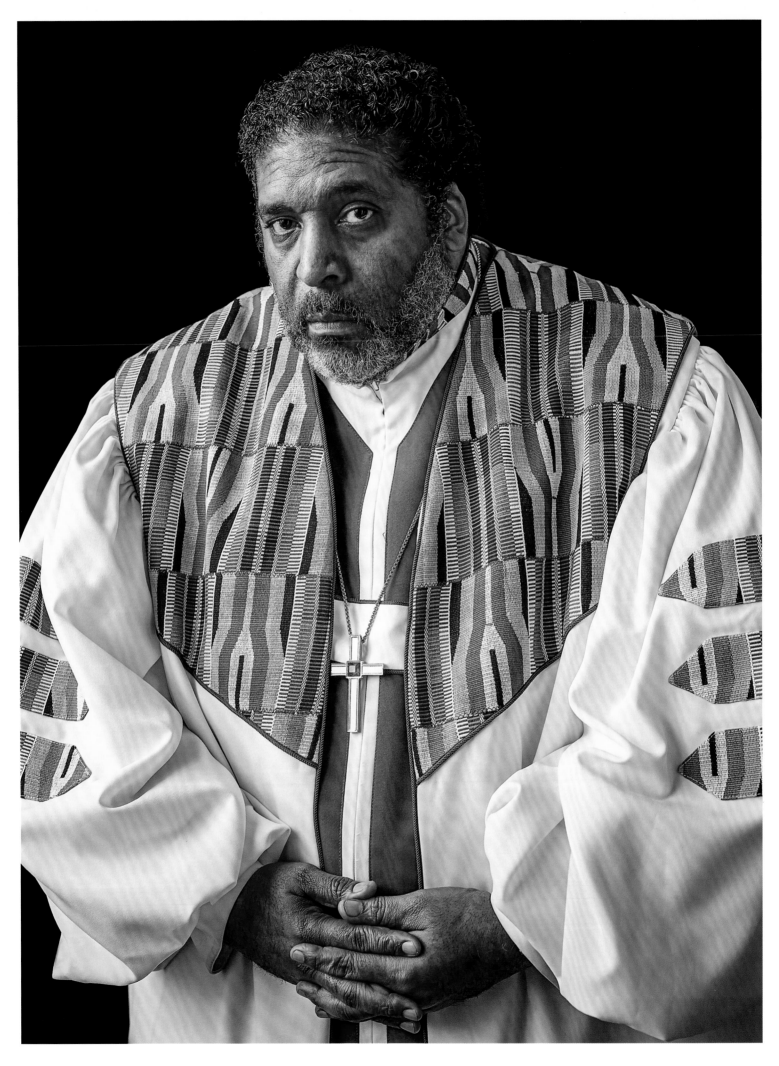

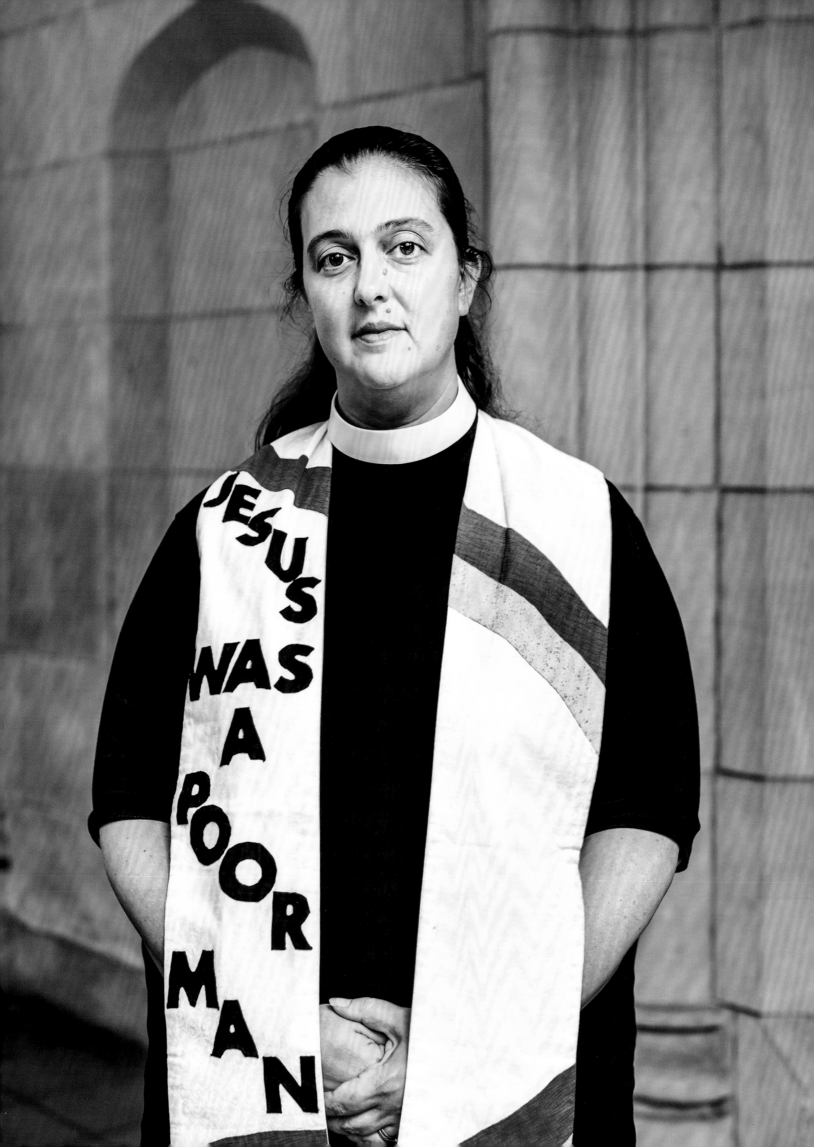

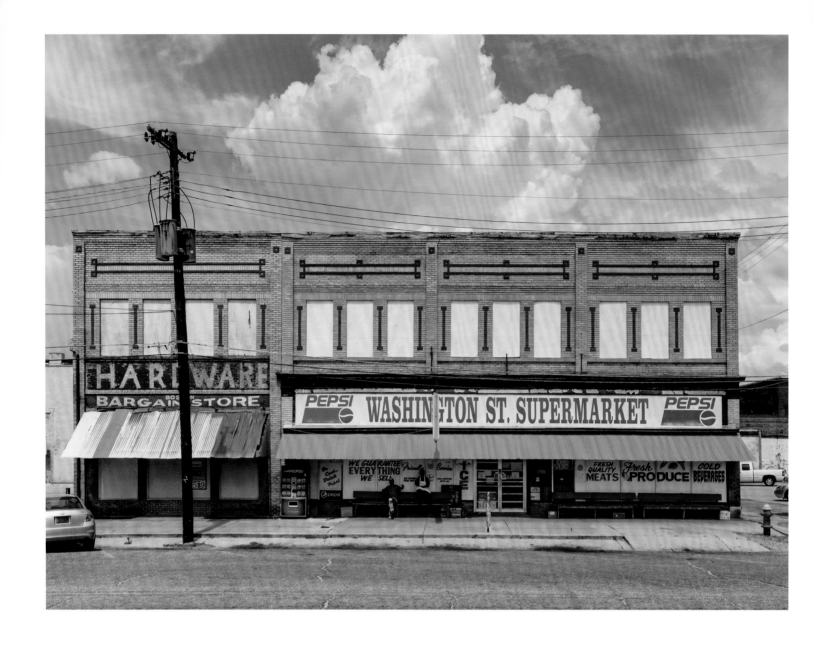

Washington Street, Selma, Alabama, 2017

During the Great Depression, Walker Evans made photographs for the Farm Security Administration, recording rural and industrial life in Alabama and other southern states. Ninety years later, many of the streets, including Washington Street in downtown Selma, remain relatively unchanged.

Houses, Selma, Alabama, 2017

Black Americans constitute 70 percent of the population in Dallas County. In 1961, the population of Dallas County was 57 percent black, but of the 15,000 Black Americans old enough to vote, only 130 were registered (fewer than 1 percent). At that time, more than 80 percent of Dallas County's Black American population lived below the poverty line. Today, 38 percent of Selma residents live below the poverty line. In 2018, Alabama voted to send the Democrat Doug Jones to the US Senate. It was a monumental victory in a solidly red state, with Black American female voters in Selma and throughout Alabama widely seen as the decisive factor in the election.

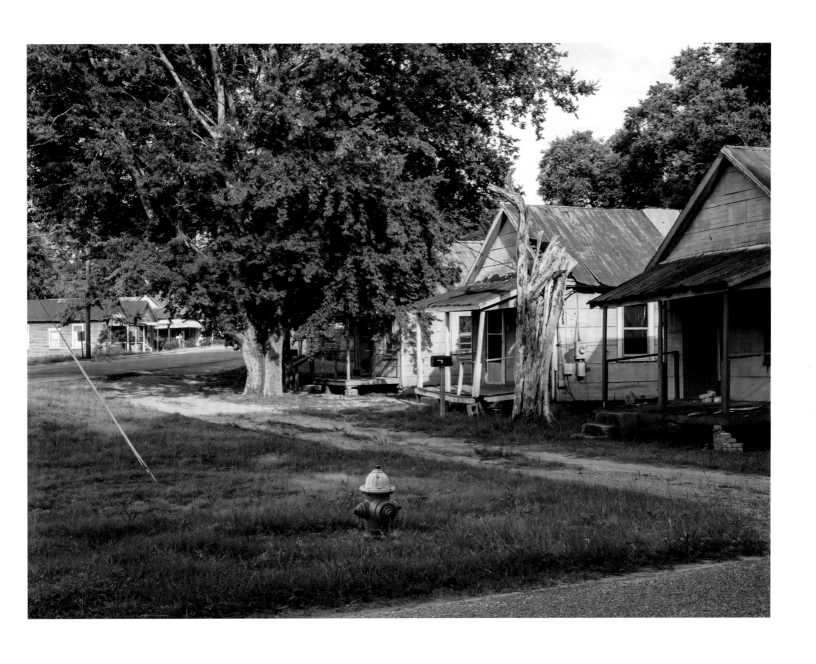

Rosa L. Parks Avenue, Montgomery, Alabama, 2017

Rosa Parks lived in the Cleveland Courts apartments in Montgomery, Alabama, located on what is now Rosa L. Parks Avenue. Two blocks from Cleveland Courts, Rosa L. Parks Avenue intersects with W Jeff Davis Avenue, named for the president of the Confederacy. Conflicting memorials such as this are common throughout much of the South.

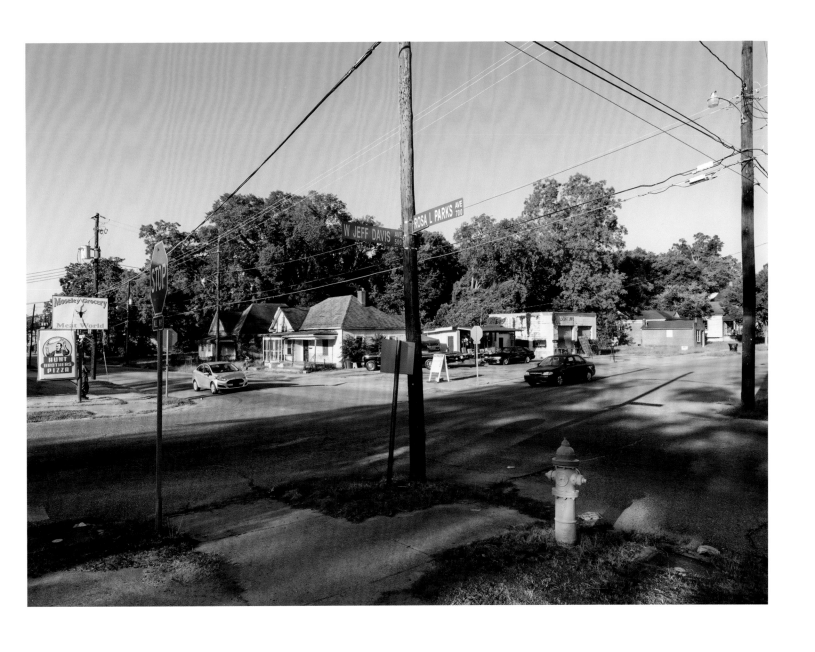

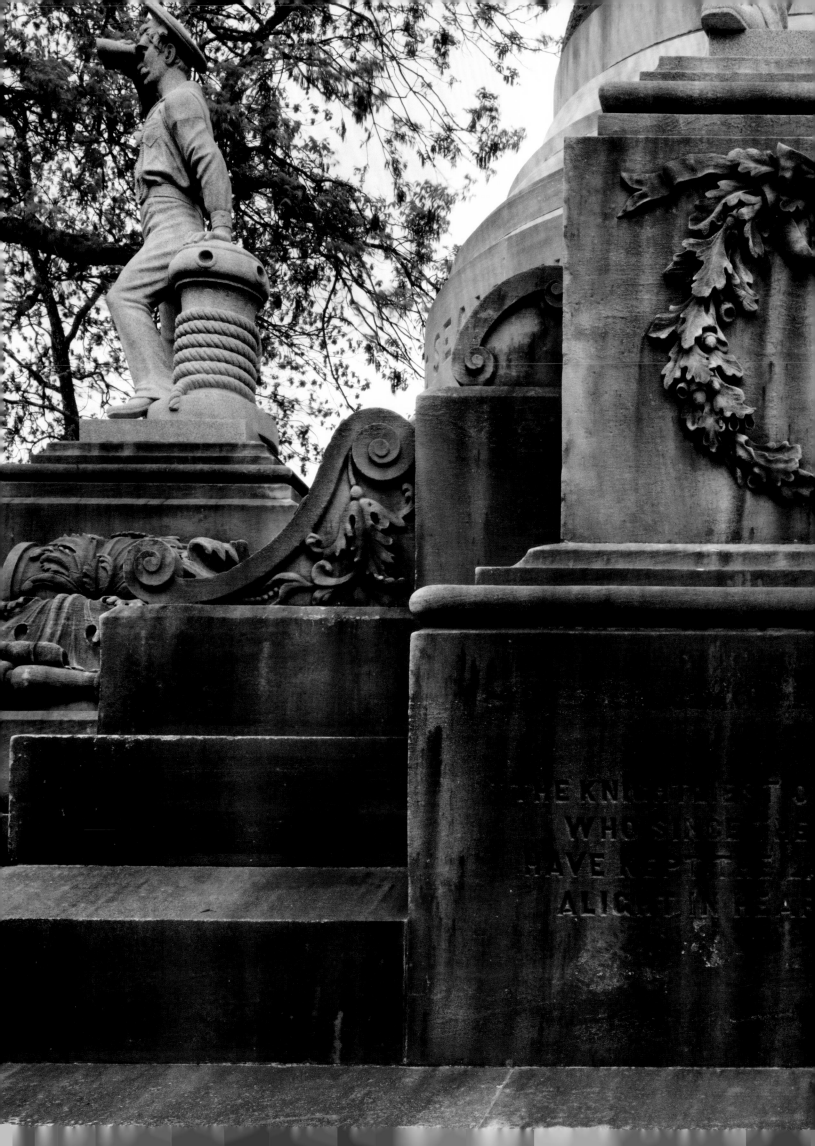

THE KN...
WHO SI...
HAVE KE...
ALIGHT IN H...

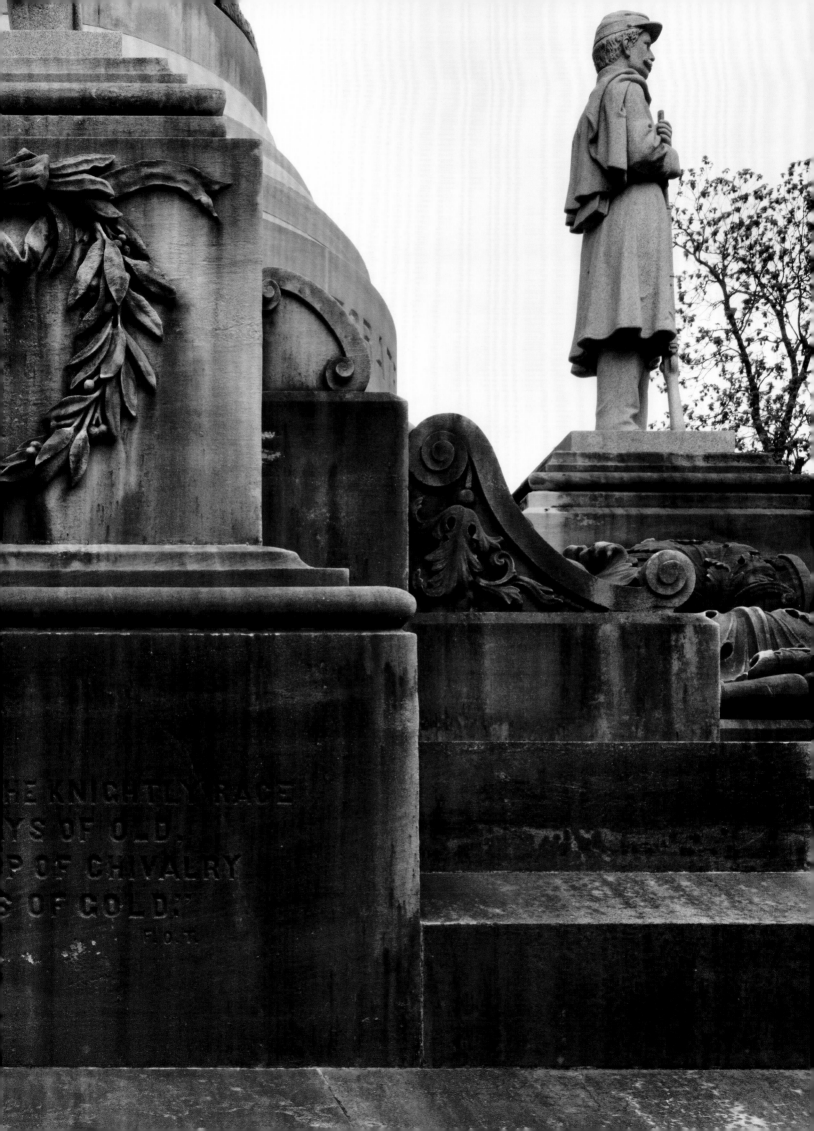

THE KNIGHTLY RACE[…]
[…]YS OF OLD,[…]
[…]P OF CHIVALRY
[…]S OF GOLD[…]
[…]FIGHT

(*previous spread*)
**Monument to the Confederacy,
Alabama State Capitol,
Montgomery, Alabama, 2018**

Beginning with the Camilla Massacre of
1868 in Camilla, Georgia, and continuing
into the early 1900s, during the period
known as Redemption, white South-
erners created nearly two thousand
monuments to the Confederacy. In 1898,
at the Alabama State Capitol in Mont-
gomery, former Confederate President
Jefferson Davis placed the cornerstone
at the eighty-eight-foot-tall Monument
to Confederate Soldiers and Sailors. One
inscription on the monument reads: *"The
knightliest of the knightly race / who
since the days of old, / have kept the
lamp of chivalry / alight in hearts of gold."*
A 2018 campaign ad with Alabama
Governor Kay Ivey calling for the pres-
ervation of Confederate monuments on
public property was condemned by the
NAACP.

**The Governor's Mansion,
Montgomery, Alabama, 2019**

This mansion is the official residence
of the Governor of Alabama. George
Wallace was a four-time governor of
Alabama and a four-time candidate for
president of the United States.

He became known as the embodiment
of resistance to the civil rights
movement in the 1960s. Later, Wallace
called segregation a mistake. During
his terms as governor, Alabama rated
near the bottom of states in per capita
income, welfare, and spending on edu-
cation. In 2020, under Governor Kay
Ivey, Alabama remains near the bottom
in each of these categories, while voter
suppression and the preservation of
Confederate monuments on state
property continue to be major issues.

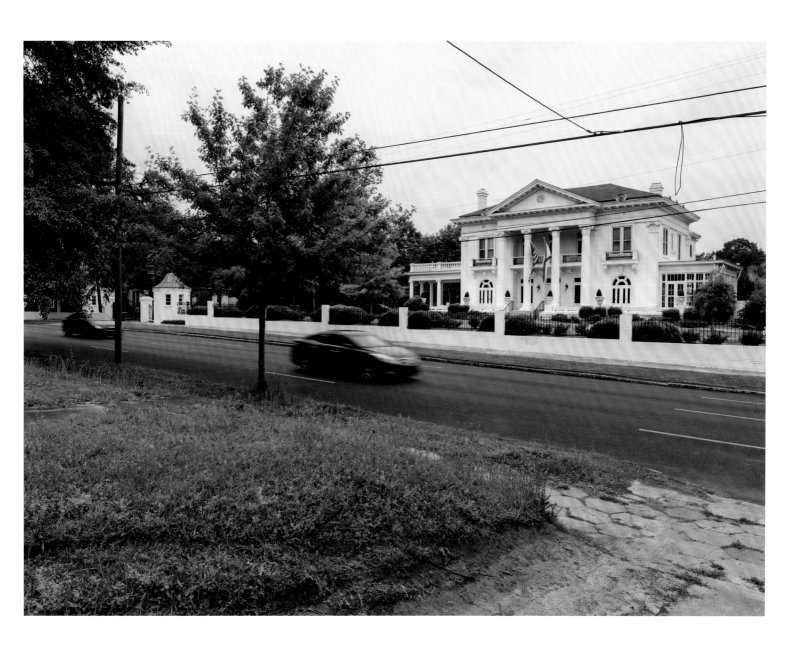

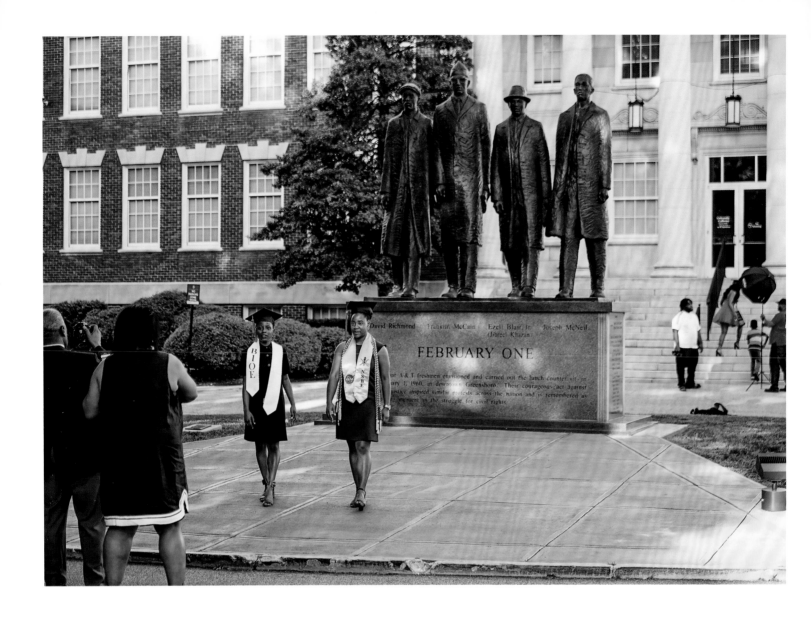

The Bradley Sisters, Greensboro, North Carolina, 2019

Sit-ins to integrate eating establishments had been occurring on a small scale for several years when, in 1960, four black freshmen from North Carolina Agricultural and Technical State University (NC A&T) walked from their campus in Greensboro, North Carolina, to the still-segregated Woolworth's five-and-dime store in the town center and sat down at the counter. From then on, the sit-in became a key tactic of nonviolence in the playbook of the civil rights move-ment. In the following weeks, months, and years, the brave students' action was replicated with peaceful sit-ins in Virginia, South Carolina, Tennessee, Florida, Maryland, Kentucky, Alabama, Texas, Arkansas, Louisiana, Georgia, and Mississippi. Sit-ins continued through 1964. A continuing graduation tradition at NC A&T includes being photographed beneath the monument to these four legendary students at the entrance to the campus.

Visitors at the United States Supreme Court, Washington, DC, 2018

On June 27, 2019, the Supreme Court ruled five-to-four that partisan gerrymandering cases present political questions that fall beyond the jurisdiction of the federal judiciary, despite having ruled numerous times on gerrymandering-related questionsin the past, including in *Gomillion v. Lightfoot* in 1960. Supreme Court Justice Elena Kagan, in her dissent on the 2019 case, wrote: "Of all times to abandon the Court's duty to declare the law, this was not the one. The practices challenged in these cases imperil our system of government. Part of the Court's role in that system is to defend its foundations. None is more important than free and fair elections. With respect but deep sadness, I dissent."

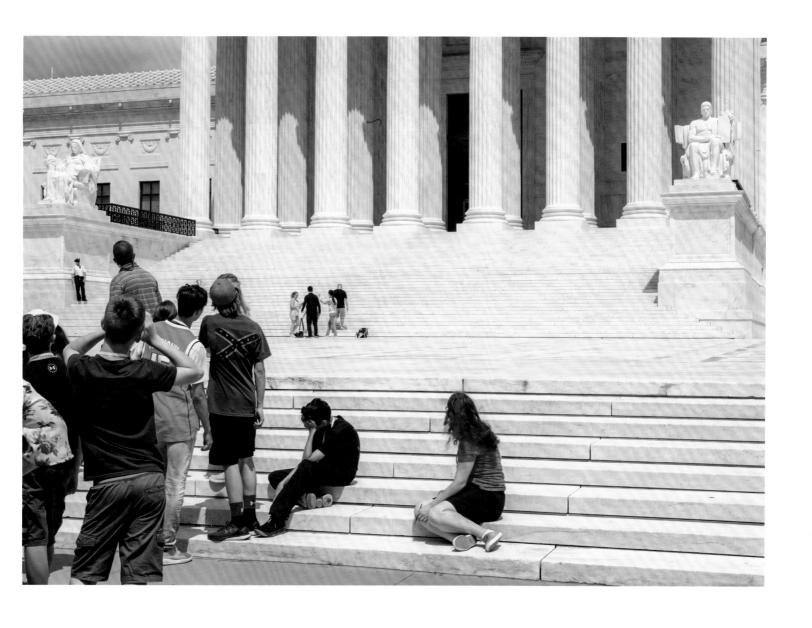

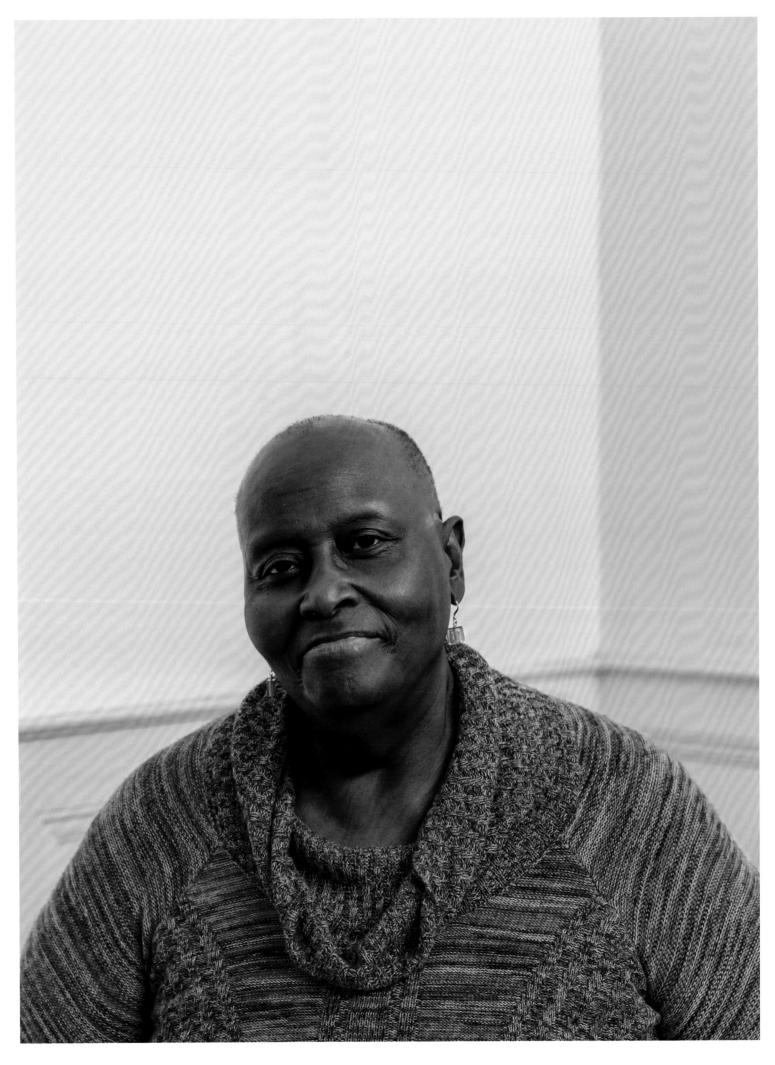

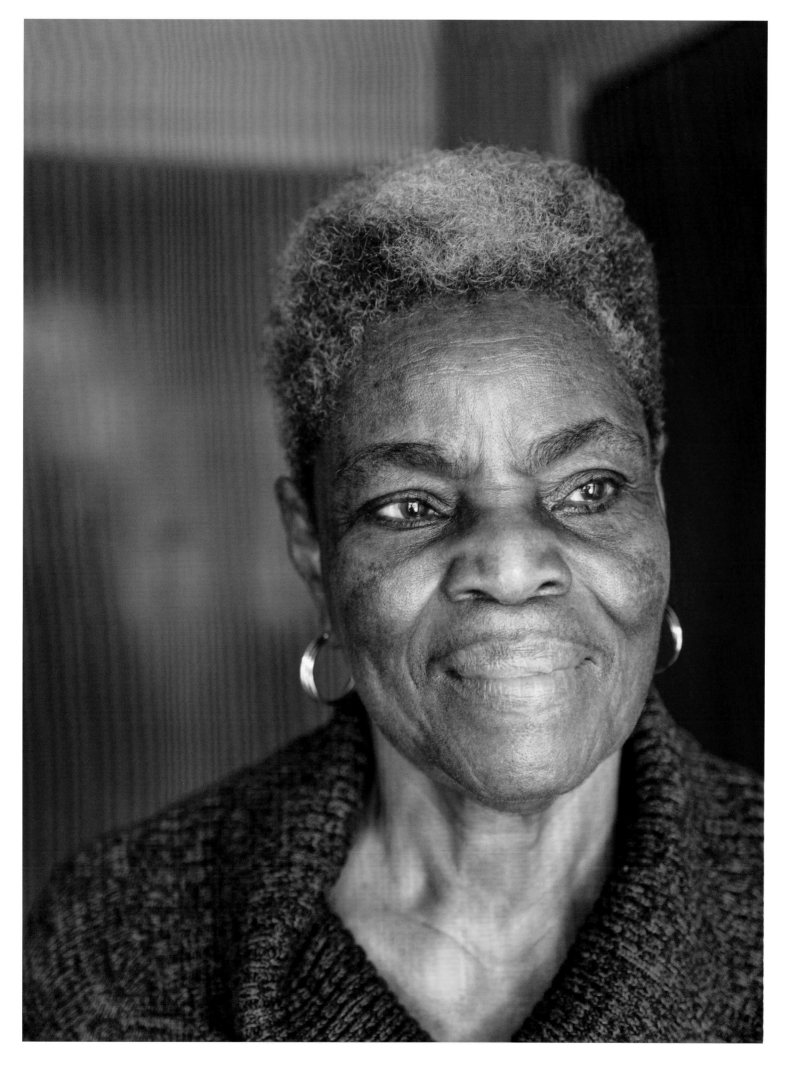

(previous spread, right)
**Minnie Watson, Jackson,
Mississippi, 2018**

Minnie Watson is the former curator of
the Myrlie and Medgar Evers Museum in
Jackson, Mississippi. She remembers the
day in 1961 when she met Medgar Evers.
Watson was attending Campbell Col-
lege, an all-black private school in Jack-
son, when Evers came to speak to their
class about joining the NAACP. Watson's
mother forbade her to join the NAACP,
so she clandestinely worked with Mr.
Evers without her mother's knowledge.
When her mother passed, Watson found
that she was a card-carrying member
herself. In 1964, Campbell College was
seized by the state in what appeared to
be a response to campus activism.

**Kimberly Merchant, Greenville,
Mississippi, 2018**

Kimberly Merchant is an attorney and
the director of the Racial Justice Institute
for the Shriver Center on Poverty Law in
the Mississippi Delta. Merchant's work
focuses on education law and the rights
of students in the areas of school disci-
pline, special education, access to public
education, restorative justice, and
education funding. Merchant has served
as a member of the board of trustees
for Greenville Public Schools and is
a municipal election commissioner for
the City of Greenville.

(previous spread, left)
**Sandy Hamilton, Memphis,
Tennessee, 2018**

At age twelve, Hamilton attended one
civil rights march where protesters were
teargassed by the Memphis police.
Returning to the Clayborn Temple after-
ward, she recalls Dr. King asking her if
she, along with others, were alright. Her
grandson now attends the Stax Music
Academy, whose students practice at the
Temple in the afternoons.

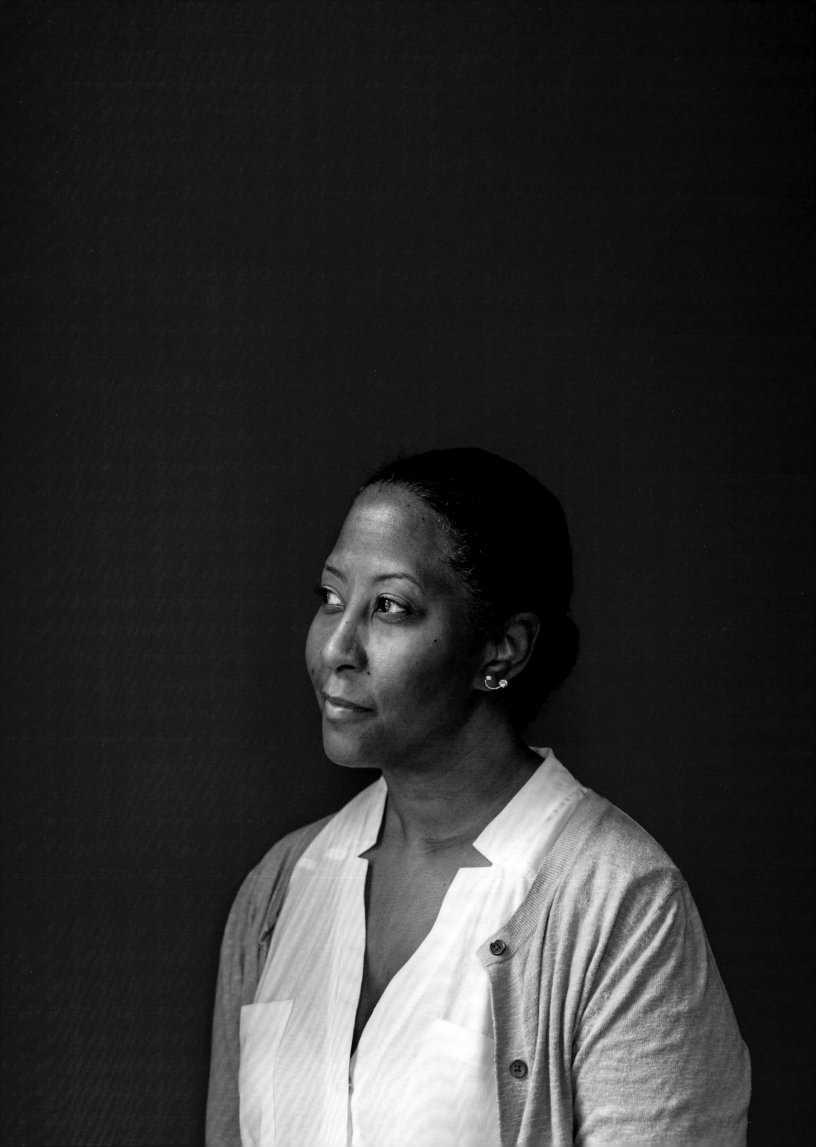

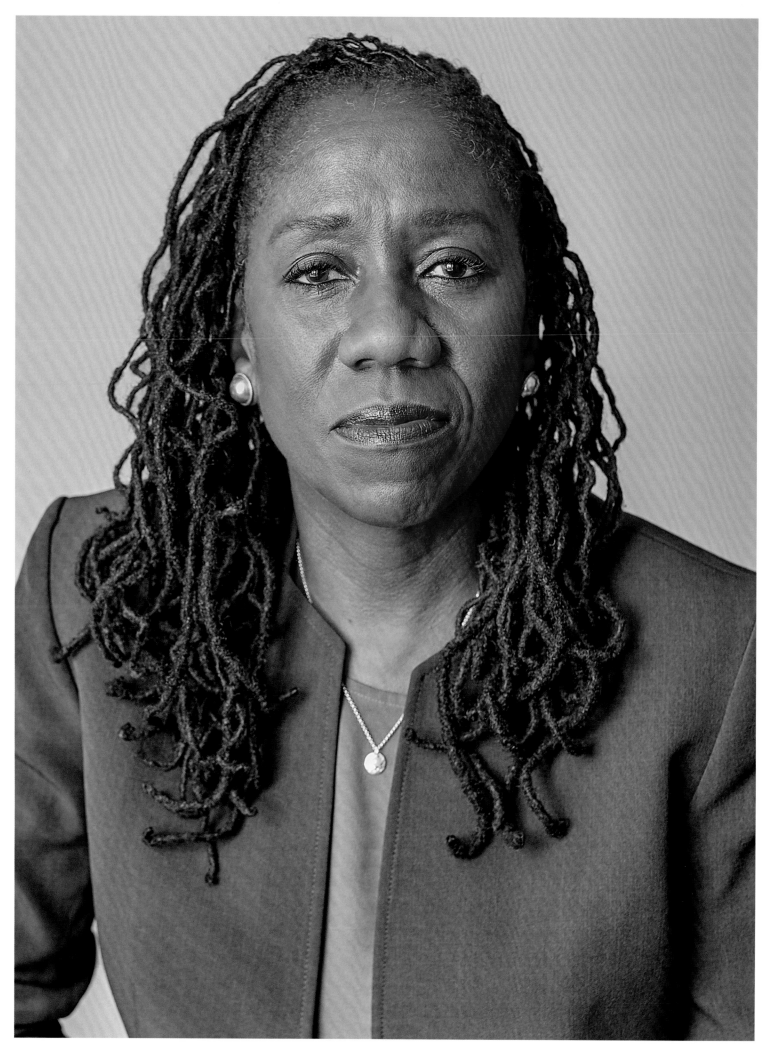

Sherrilyn Ifill, New York, 2019

Sherrilyn Ifill is the president and direc-
tor-counsel of the NAACP Legal Defense
and Educational Fund (LDF), founded
in 1940 by legendary civil rights lawyer
(and later Supreme Court justice) Thur-
good Marshall. The LDF has fought for
decades to protect the vitality of the
Voting Rights Act. Ifill says: "Racially dis-
criminatory voter suppression, attacks
on election security, disenfranchisement
of formerly incarcerated citizens,
byzantine local election systems that
seem designed to discourage citizens
from registering and voting have jeop-
ardized equal voting rights in this coun-
try, turning what should be a source of
national pride into a serious cause for
alarm. We do not have to accept this
'new normal.' We can push Congress to
restore the Voting Rights Act to its full
power. We can demand at the state and
local level, the adoption of automatic
voter registration, early voting, and the
restoration of voting to formerly
incarcerated citizens. This is the real
work and responsibility of citizenship
in a democracy that is worth it."

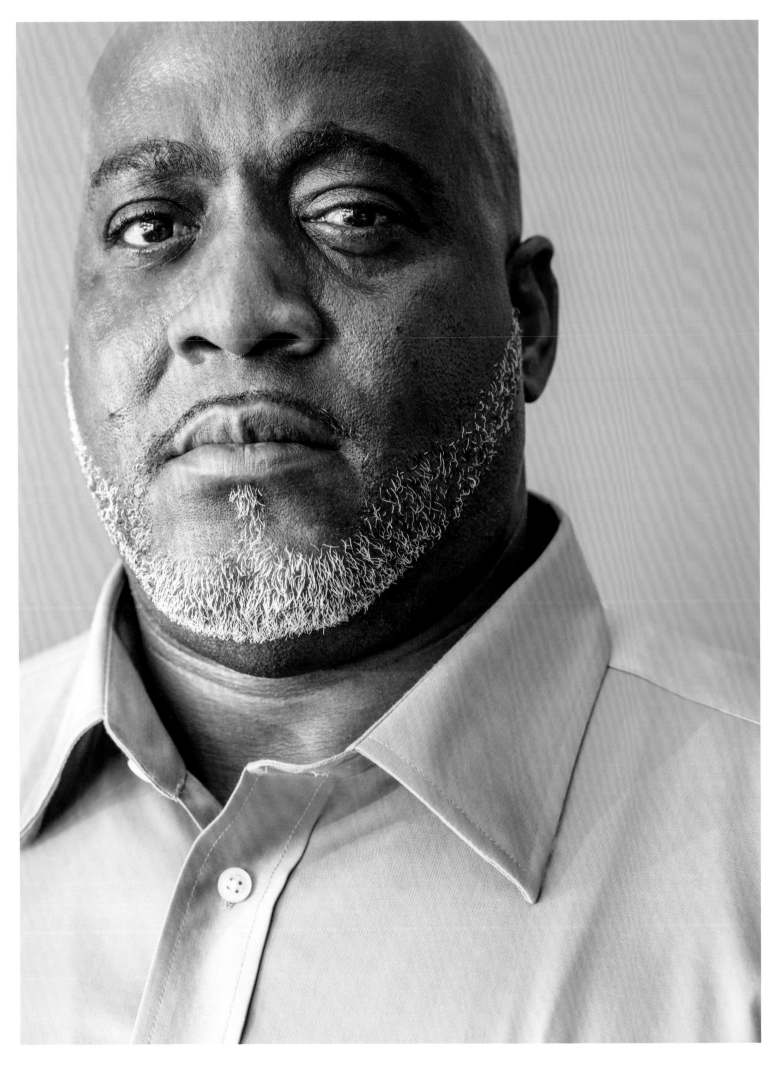

**Desmond Meade,
Orlando, Florida, 2019**

Desmond Meade was once homeless.
Now he is president of the Florida Rights
Restoration Coalition (FRRC). In 2018,
Meade rallied Florida voters to over-
whelmingly pass Amendment 4 to the
state's constitution, which extended vot-
ing eligibility to ex-felons. FRRC's efforts
have fueled nationwide momentum for
the restoration of rights to people with
past criminal convictions. In 2019, Flor-
ida's Republican-majority legislature
proposed altering the amendment's lan-
guage with a new bill requiring felons to
reimburse the state for the cost of their
incarceration before voting rights would
be restored. An FRRC representative
referred to the change as a "poll tax."
Civil rights groups and felons filed
a consolidated lawsuit to prevent the
changes from becoming law.

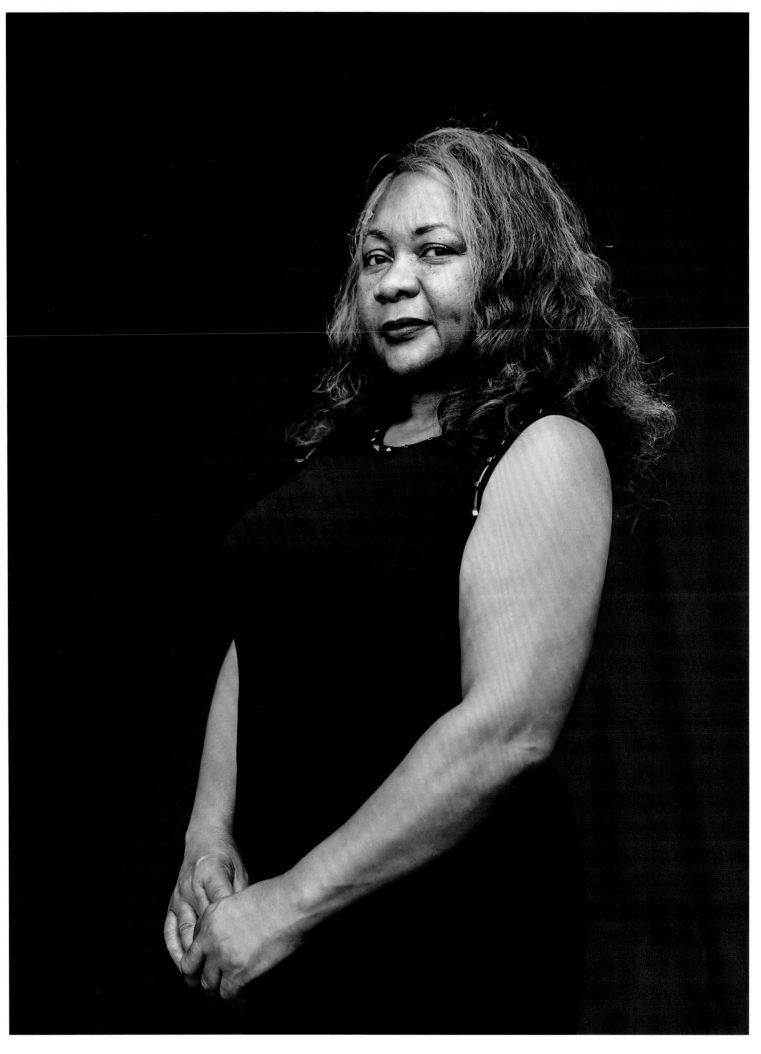

**Catherine Flowers, Holy Ground
Battlefield Park, Lowndes County,
Alabama, 2019**

Catherine Coleman Flowers grew up in
Lowndes County, Alabama. She is an
environmental justice activist with the
Center for Earth Ethics and the Alabama
Center for Rural Enterprise (ACRE).
ACRE addresses the lack of sewage
disposal infrastructure in Alabama's
rural Black Belt, a legacy of racism and
neglect stretching back to the time of
slavery. Flowers is also the rural develop-
ment manager for the Equal Justice Ini-
tiative. Lowndes County is one of the ten
poorest counties in Alabama's Black Belt.
After a 2017 visit there with Flowers,
the UN special rapporteur on extreme
poverty and human rights, Philip Alston,
observed raw sewage outside peo-
ple's homes and in open front-yard pits.
Alston said that he had "never seen this
in the first world."

(*following spread, left*)
**Bryan Stevenson, Montgomery,
Alabama, 2018**

The attorney Bryan Stevenson is the
founder of the Equal Justice Initiative
(EJI), based in Montgomery. The EJI has
won major legal challenges: eliminating
excessive and unfair sentencing, exon-
erating innocent death row prisoners,
confronting abuse of the incarcerated
and the mentally ill, and aiding children
prosecuted as adults. He led the creation
of two highly acclaimed museums that
opened in 2018: the Legacy Museum
and the National Memorial for Peace and
Justice. In 2019, Stevenson said: "If you
care about people who are marginalized,
if you care about the poor, the excluded,
the disabled, the disenfranchised, then
you have to vote."

(*following spread, right*)
**Memorial for Peace and Justice,
Montgomery, Alabama, 2018**

The Memorial for Peace and Justice in
Montgomery, Alabama, was created by
Bryan Stevenson and the Equal Jus-
tice Initiative. The site, which opened
in 2018, chronicles our nation's history
of slavery, lynching, and segregation, as
well as the enduring legacies of other
forms of injustice: mass incarceration,
voter suppression, and racial bias. Span-
ning a six-acre plot, the monument over-
looks the city of Montgomery.

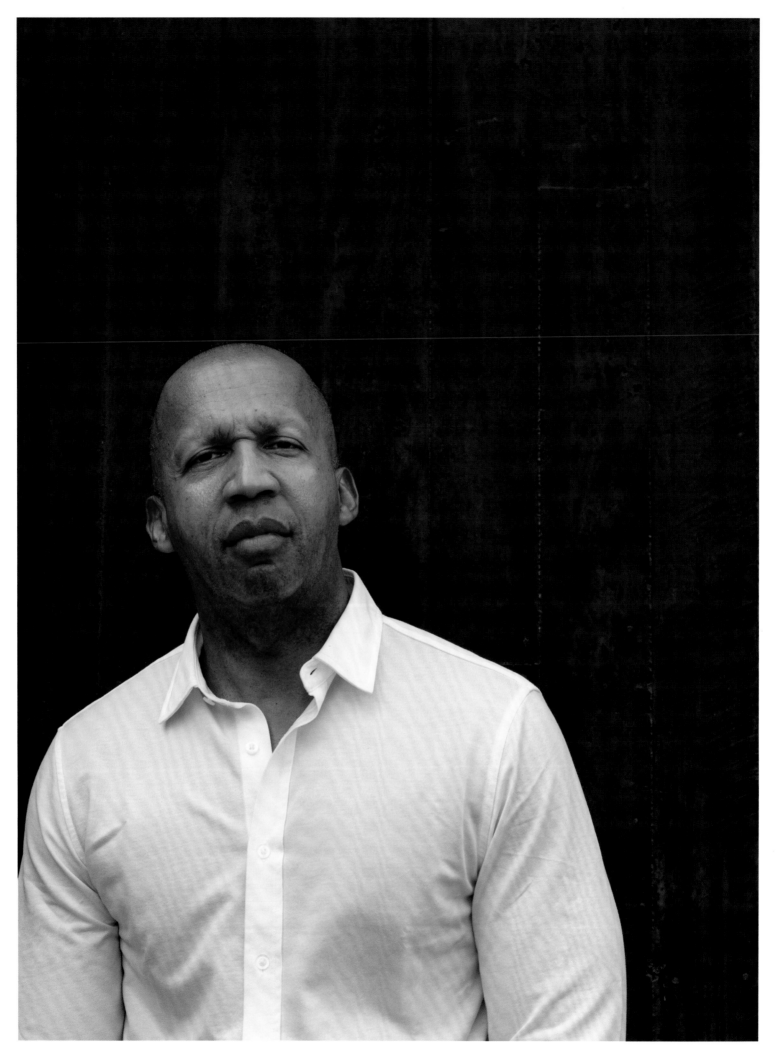

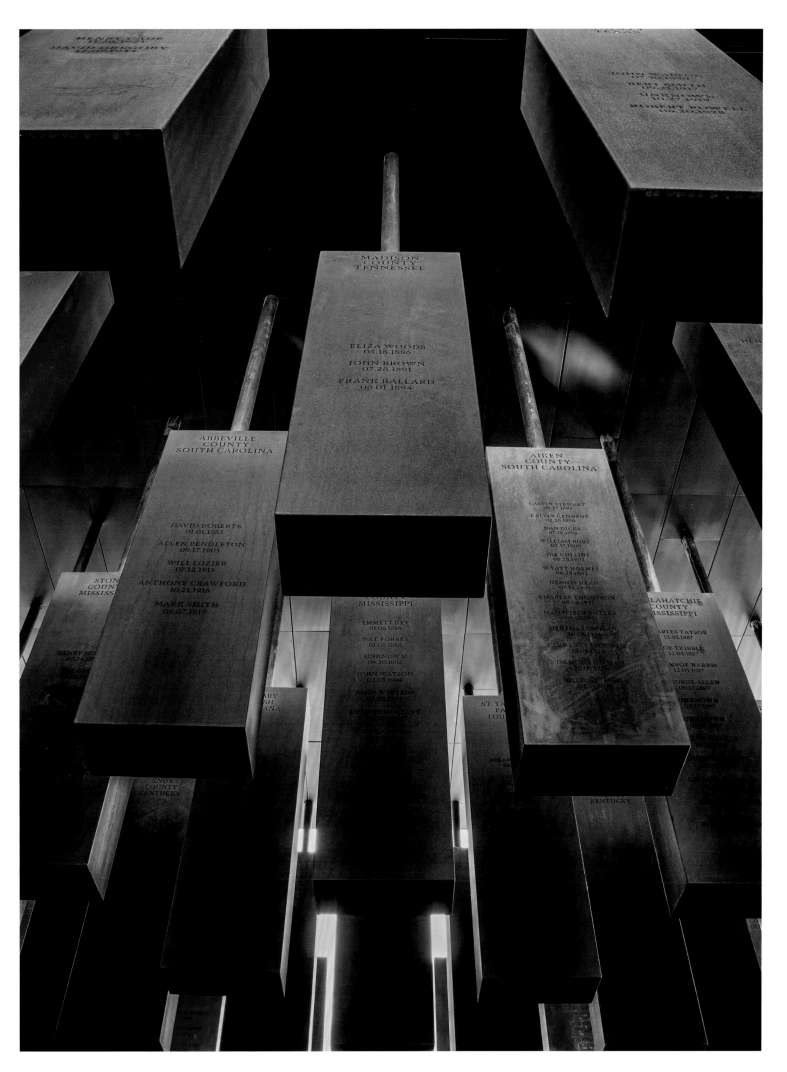

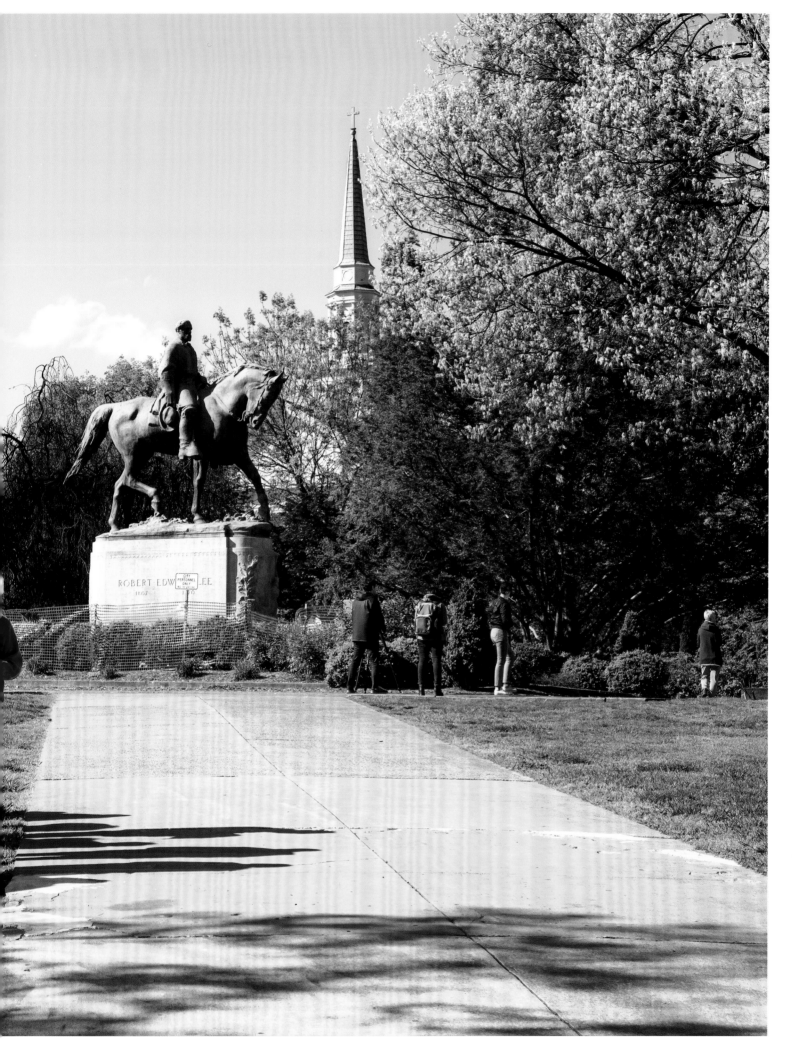

(*previous spread*)
Market Street Park, Site of the Unite the Right Rally, Charlottesville, Virginia, 2018

The Unite the Right Rally of 2017 was a white supremacist march opposing the removal of the statue of Robert E. Lee from Charlottesville's Emancipation Park (called Lee Park until just a few months before the rally, and now named Market Street Park). Counterprotester Heather Heyer was killed when a white supremacist drove a car into the crowd. Responding to the events the next day, President Donald Trump said, "But you also had people that were very fine people on both sides," a statement that many saw as condoning the violence. The Southern Poverty Law Center reported that white supremacists were responsible for the deaths of at least forty people in North America over the following year.

Robyn Easter, Greensboro, North Carolina, 2019

Robyn Easter, an actress and singer, works as a docent at Greensboro's International Civil Rights Museum. On her tours at the museum, Easter's passion encourages confrontations with stereotypes and reigning historical interpretations of the civil rights movement and its leaders, particularly the role of women in the movement. The Woolworth's counter where antisegregation student sit-ins began in 1960 is preserved in the museum.

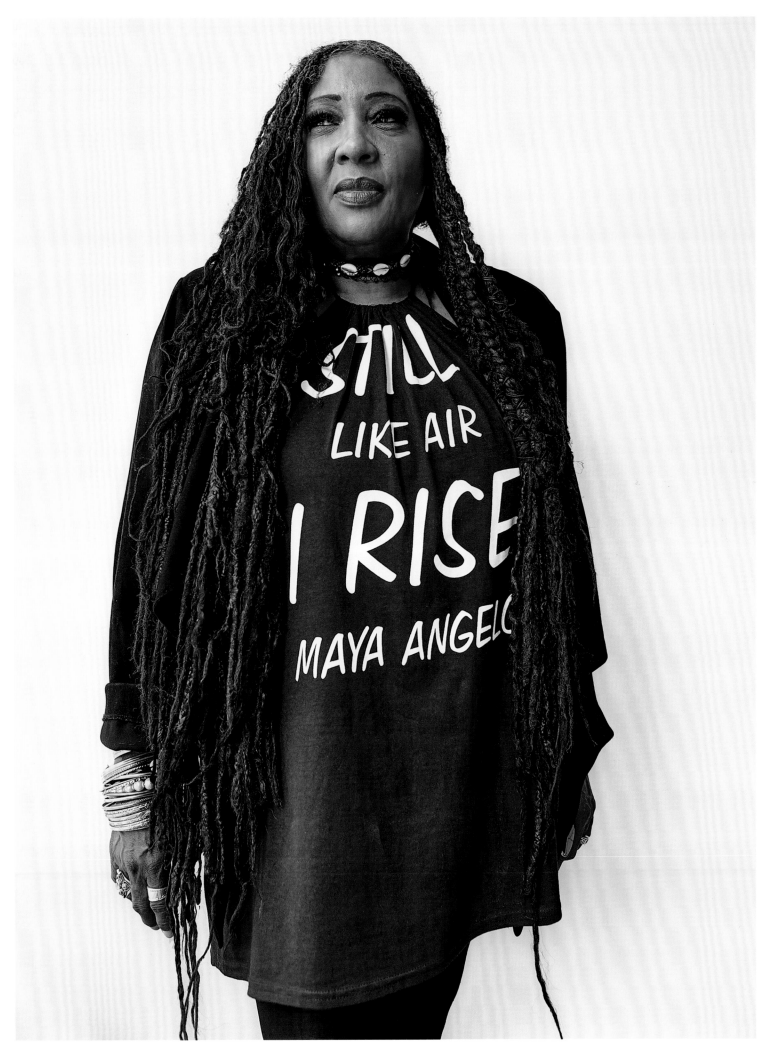

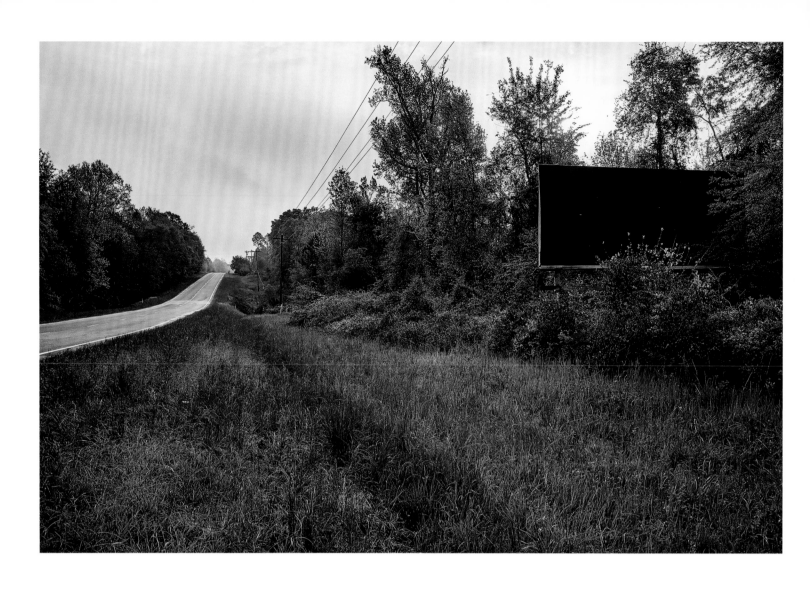

Road from Americus to Plains, Georgia, 2019

The Americus Movement of 1963 followed voting and civil rights efforts in nearby Albany, Georgia, that had taken place earlier. Plains, the home of former President and Mrs. Carter, sits ten miles from Americus. In 1965, the Plains Baptist Church, where President Carter was a deacon, passed a resolution barring "Negroes and civil rights agitators" from the church, though Mr. Carter opposed the resolution at the time and again in 1976, when it was brought up a few days before his election. After his presidency, the Carters left Plains Baptist to join a church founded by other Plains residents opposing the resolution. President Carter still teaches a Sunday school class there every week.

(*following spread*)
Selma, Alabama, 2017

Some 3,000 people died during the Battle of Selma on April 2, 1865 (359 Union and 2,700 Confederate). One hundred years after that battle, Selma again became the site of an epic event: the Selma-to-Montgomery Marches of 1965. To an outsider viewing Selma today, William Faulkner's famous line, "The past is never dead, it's not even past," perfectly characterizes the city's atmosphere.

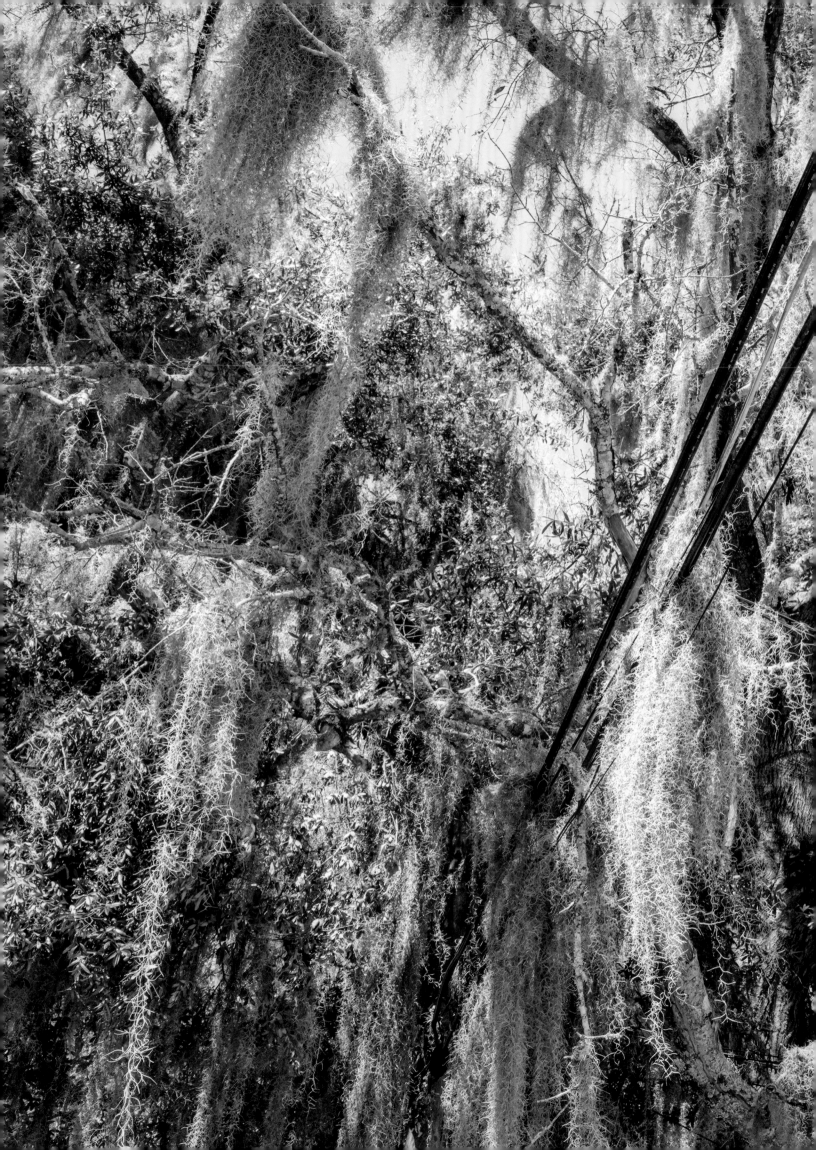

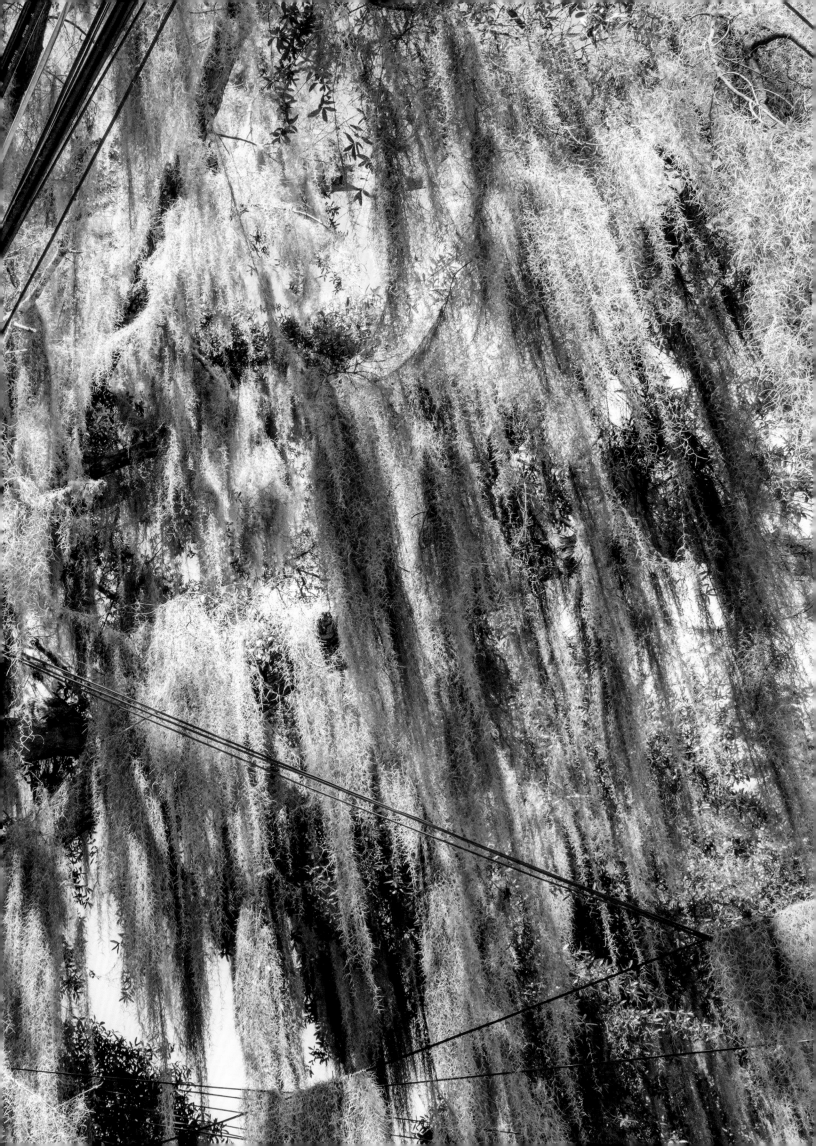

Any person who does not vote is failing to serve the cause of freedom—His own freedom, his people's freedom, and his country's freedom.

CONSTANCE BAKER MOTLEY

FURTHER READING

Alexander, Michelle. *The New Jim Crow: Mass Incarceration in the Age of Colorblindness*. New York: New Press, 2010.

Anderson, Carol. *One Person, No Vote: How Voter Suppression is Destroying our Democracy*. New York: Blooms-bury, 2018.
—— *White Rage: The Unspoken Truth of Our Racial Divide*. New York: Bloomsbury, 2016.

Baldwin, James. *The Cross of Redemption: Uncollected Writings*. New York: Vintage International, 2010.
—— *The Fire Next Time*. 1962. New York: Vintage International, 1990.
—— *Notes of a Native Son*. 1955. Boston: Beacon, 1983.

Barber, Rev. Dr. William J. II, and Jonathan Wilson-Hartgrove. *The Third Reconstruction: How a Moral Movement Is Overcoming the Politics of Division and Fear*. Boston: Beacon, 2016.

Berman, Ari. *Give Us the Ballot: The Modern Struggle for Voting Rights in America*. New York: Picador/Farrar, Straus and Giroux, 2016.

Branch, Taylor. *At Canaan's Edge: America in the King Years 1965–68*. New York: Simon and Schuster, 2006.
—— *Parting the Waters: America in the King Years 1954–63*. New York: Simon and Schuster, 1988.
—— *Pillar of Fire: America in the King Years 1963–65*. New York: Simon and Schuster, 1998.

Carrier, Jim. *A Traveler's Guide to the Civil Rights Movement*. Orlando, FL: Harvest, 2004.

Carson, Clayborne, David J. Garrow, Bill Kovach, and Carol Polsgrove, comps. *Reporting Civil Rights, Part One: Ameri-can Journalism 1941–1963*. Library of America Classic Journalism Collection. New York: Library of America, 2003.
—— *Reporting Civil Rights, Part Two: American Journalism 1963–1973*. Library of America Classic Journalism Collection. New York: Library of America, 2003.

Charles River Editors. *The Mississippi Burning Case: The History and Legacy of the Freedom Summer Murders at the Height of the Civil Rights Movement*. Middletown, DE: Charles River Editors, 2018.

Coates, Ta-Nehisi. *Between the World and Me*. New York: Random House, 2015.
—— *We Were Eight Years in Power: An American Tragedy*. New York: One World, 2017.

Dees, Morris, and Steve Fiffer. *A Lawyer's Journey: The Morris Dees Story*. Chicago: The American Bar Associa-tion, 2001.

Dyson, Michael Eric. *Tears We Cannot Stop: A Sermon to White America*. New York: St. Martin's, 2017.
—— *What Truth Sounds Like: RFK, James Baldwin, and Our Unfinished Conversation About Race in America*. New York: St. Martin's Press. 2018.

Gaillard, Frye, et al. *Alabama's Civil Rights Trail: An Illustrated Guide to the Cradle of Freedom*. Tuscaloosa: University of Alabama Press, 2010.

Gordon, Linda. *The Second Coming of the KKK*. New York: Liveright, 2017.

Halberstam, David. *The Children*. New York: Fawcett Books, 1998.

Hartford, Bruce, *Troublemaker: Memories of the Freedom Movement*. San Francisco: Westwind Writers, 2019.

Keyssar, Alexander. *The Right to Vote: The Contested History of Democracy in the United States*. New York: Basic Books, 2000.

Landrieu, Mitch. *In the Shadow of Statues: A White Southerner Confronts History*. New York: Viking, 2018.

Leamer, Laurence. *The Lynching: The Epic Courtroom Battle That Brought Down the Klan*. New York: William Morrow, 2016.

Levingston, Steven. *Kennedy and King: The President, the Pastor, and the Battle over Civil Rights*. New York: Hachette, 2017.

Lewis, John, and Michael D'Orso. *Walking with the Wind: A Memoir of the Movement*. New York: Simon and Schuster, 1998.

Litt, David. *Thanks, Obama: My Hopey, Changey White House Years*. New York: Ecco, 2017.

McWhorter, Diane. *Carry Me Home: Birmingham, Alabama: The Climactic Battle of the Civil Rights Revolution*. New York: Simon and Schuster, 2001.

Mitchell, Jerry. *Race Against TIme: A Reporter Reopens the Unsolved Murder Cases of the Civil Rights Era*. New York: Simon and Schuster, 2020.

Motley, Constance Baker. *Equal Justice Under Law*. New York: Farrar, Straus and Giroux, 1998.

Noxon, Christopher. *Good Trouble: Lessons from the Civil Rights Playbook*. New York: Abrams, 2018.

Phillips, Patrick. *Blood at the Root: A Racial Cleansing in America*. New York: Norton, 2016.

Pratt, Robert A. *Selma's Bloody Sunday: Protest, Voting Rights, and the Struggle for Racial Equality*. Baltimore, MD: John Hopkins University Press, 2017.

Silverstein, Jake, and Nikole Hannah-Jones, editors. *The New York Times Magazine 1619 Project*. The New York Times, 2019.

Stevenson, Bryan. *Just Mercy: A Story of Justice and Redemption*. New York: Spiegel and Grau, 2014.

Theoharis, Jeanne. *A More Beautiful and Terrible History: The Uses and Misuses of Civil Rights History*. Boston: Beacon, 2018.

Tyson, Timothy B. *The Blood of Emmett Till*. New York: Simon and Schuster, 2017.

Ward, Jesmyn. *The Fire This Time: A New Generation Speaks about Race*. New York: Scribner, 2016.
—— *Men We Reaped*. New York: Bloomsbury, 2013.

Watson, Bruce. *Freedom Summer: The Savage Season of 1964 That Made Mississippi Burn and Made America a Democracy*. New York: Penguin, 2010.

Wright, Richard. *Black Boy (American Hunger)*. New York: HarperCollins, 1945.

ACKNOWLEDGEMENTS

I would like to thank each participant in this project—those whose stories I told, those whose photographs I took, all who are mentioned, and those who graciously assisted in helping us to connect to one another.

Nikole Hannah-Jones gave me beautiful, powerful words. She is the definition of a patriot, a national treasure, and continues to teach America about the importance of honesty in our history, without which healing is not possible.

I am deeply indebted to the staff and editors of the University of Texas Press, especially Robert Devens, David Hamrick, Robert Kimzey, Gianna LaMorte, Sarah McGavrick, Joel Pinckney, and Linda Ronan, as well as Don Carleton and the staff of the Dolph Briscoe Center for American History at the University of Texas. I am honored to have the photographs from this book included in the center's important civil rights photography collection. Matt Avery produced a beautiful design and endured a fair amount of neurosis with my adjustments and questions.

Additional thanks to Stacey Abrams, Frances Anderton, David Bowman, Luke Celenza, Wayne Coleman, Jessica Daly, DaVonne Darby, Jeffrey Dungan, Connie Dyson, Larry Fink, Cliff Fong, Trip Gabriel, Adam Glassman, Daun and Peter Hauspurg, Chester Higgins, Alan Howard, Gabby Jones, Chris Kissock, Stephen Roach Knight, Becky Lewis, Mark Magowan, David Marsh, Xandre McCleary Walter McGowan, Rebekah Mikhale, Elyse Moody, Joel Motley, Reina Nakagawa, Craig Peralta, Terree Randall, Evelyne Ryan, Mayer Rus, Benjamin Saulsberry, Samantha Slosberg, Noelle Thurin, Michael Van Horne, Patrick Weems, Merele Williams, and Oprah Winfrey.

My wife, Andrea, fed me when I would not look up, debated with me, endured weeks with my being gone, encouraged me, and proofread one manuscript after another. My collaborators and progeny always help me: my son Zander brought thoughtful research, concise writing, and encouragement when I needed it; my other son, Simon, led me through the micro- and macro-issues of design and type and rhythmically finessed the visuals to match what I felt but could not explain; and Maxie, my daughter, offered thoughtful commentary that made me consider things in ways of which only she is capable.

We produced this work together through a very difficult time in our nation's history and in our individual lives. I hope the work helps foster the desperate need to understand that American history is stuck on repeat, but with honesty and love, we can end the cycle that denies justice and equality to too many of our brothers and sisters.